MEOW

A book of happiness for cat lovers

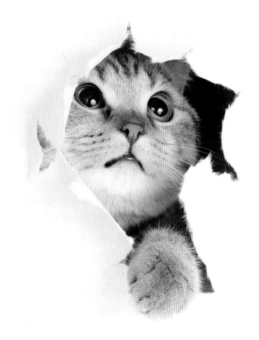

EXISLE
PUBLISHING

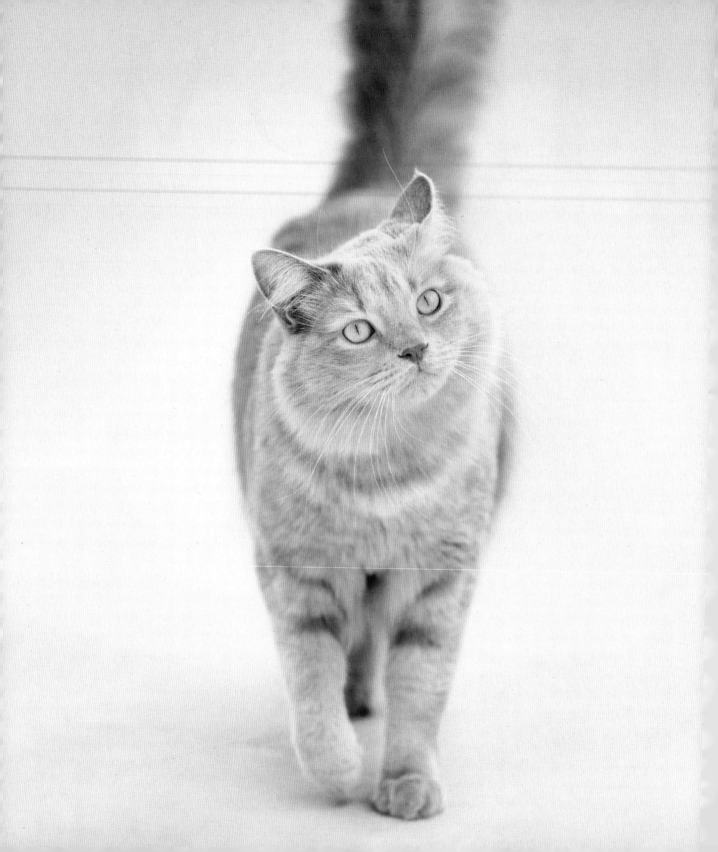

Introduction

Cats. They've been worshipped and revered since time immemorial.
They've also been reviled and despised. For the same aloof pose,
penetrating gaze and rippling-silk movement that inspires adoration can
also inspire distrust in those not willing to succumb to the charm of the cat.

Cat lovers, though, know that there is no better experience in life than
to be on the receiving end of a cat's affection — or even mere attention.
For with a cat on your lap or underfoot, the world is simply a better
place. Their very being is testament to the fact that life is to be lived
in the moment, completely, without restraint and with single-minded
purpose. They are wilful, independent, infuriating and bewitching.
And when they choose you as theirs, you are privileged indeed.

This collection of quotes spans the centuries: from Theocritus in the third
century BC, past Sir Walter Scott, Mark Twain and Ernest Hemingway,
right up to the present day. Not all the quotes are from famous people.
Not all are serious or profound. And they are arranged in no particular
themes or order. But what they all have in common is that they capture
an essential truth about our feline friends.

The result is a book to be enjoyed, savoured and dipped into again and
again. An anthology to make you smile, reflect and perhaps reminisce.

It's undoubtedly one of which every cat will approve.

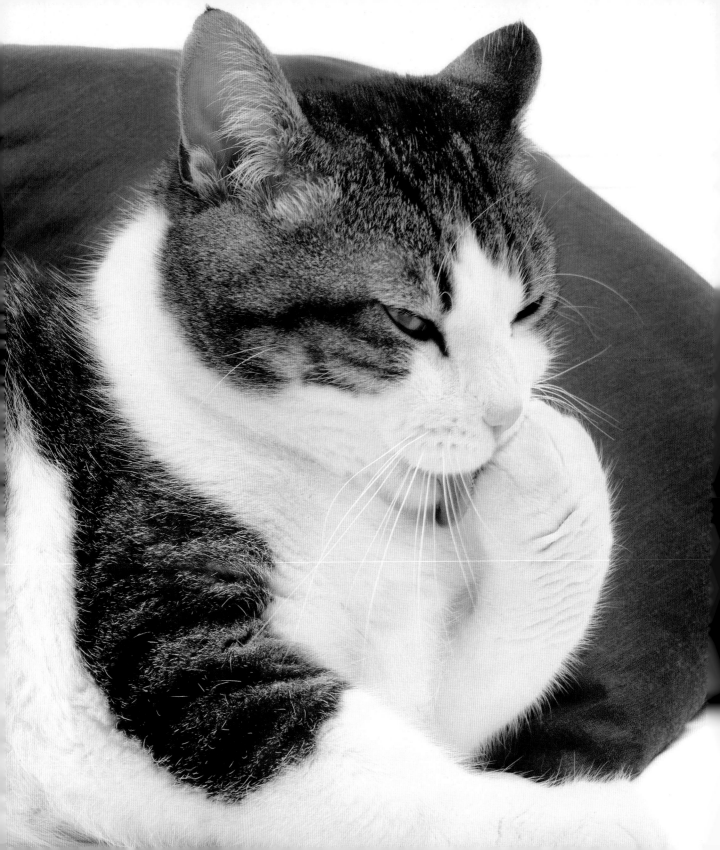

With the qualities of cleanliness, affection, patience, dignity and courage that cats have, how many of us, I ask you, would be capable of becoming cats?

FERNAND MERY

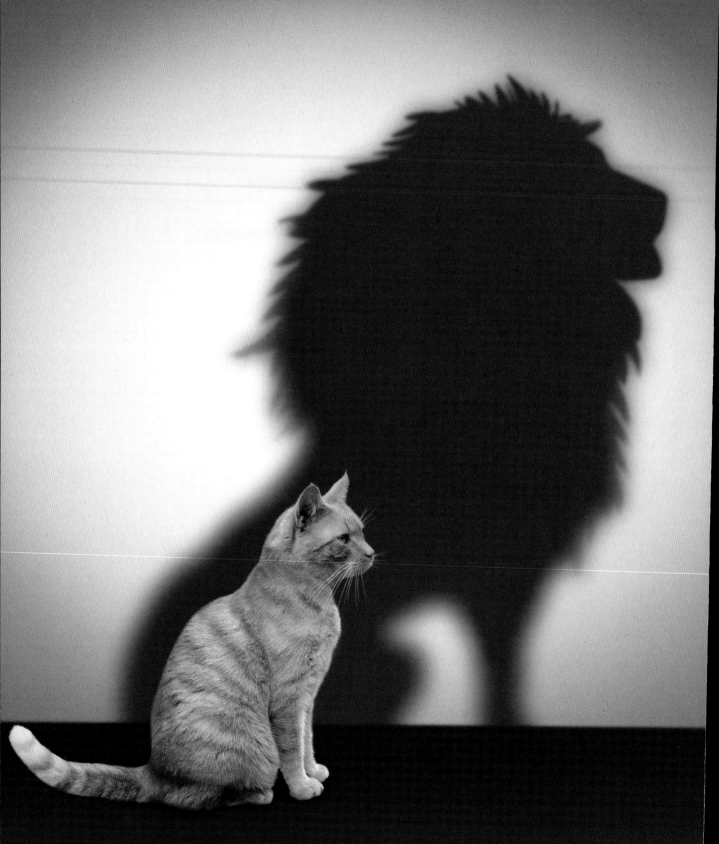

Thousands of years ago,
cats were worshipped as gods.
Cats have never forgotten this.

ANONYMOUS

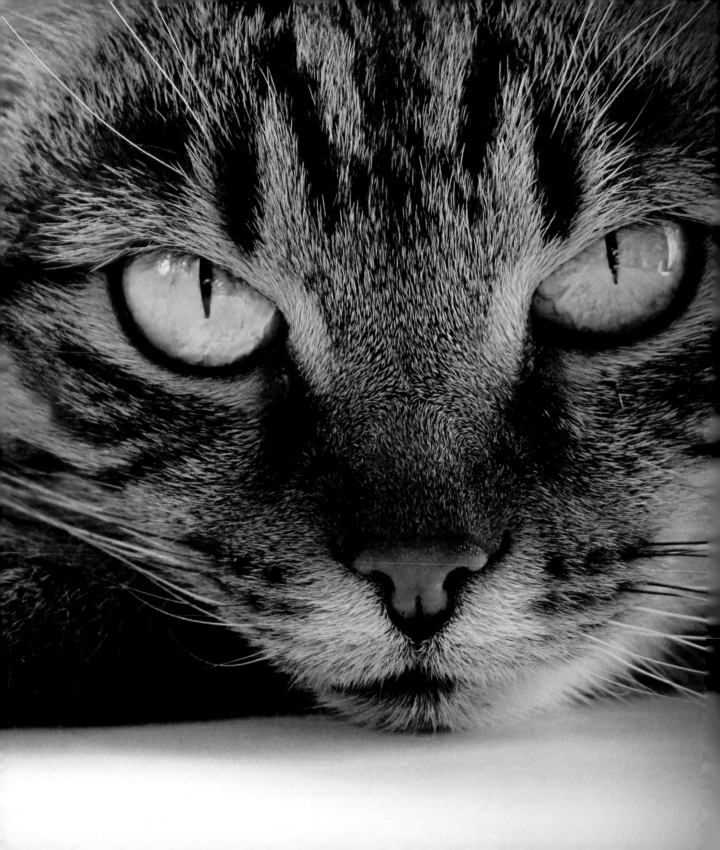

Who can believe that
there is no soul behind
those luminous eyes!

THEOPHILE GAUTIER

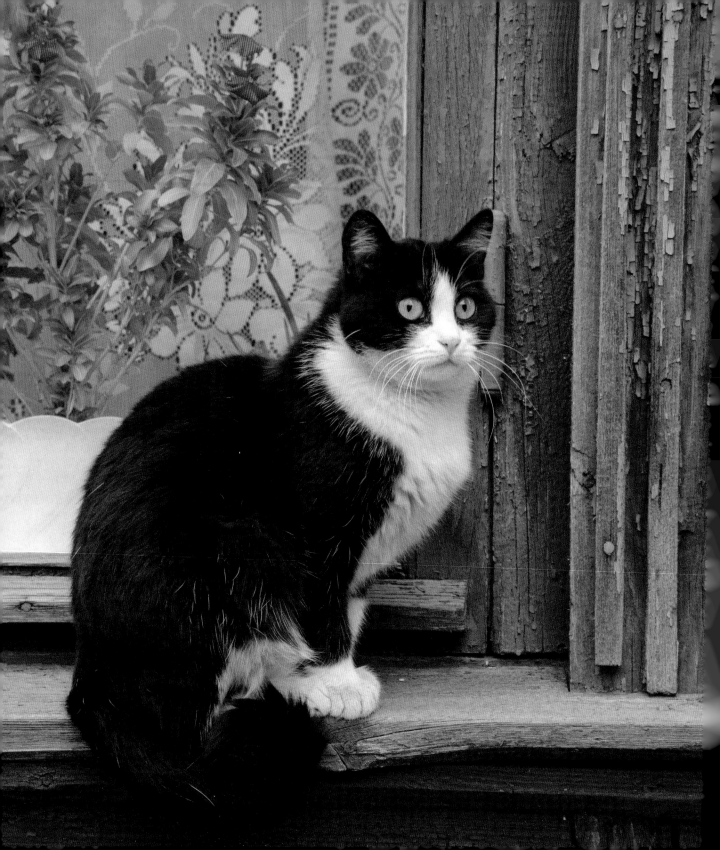

I love cats because
I enjoy my home; and
little by little, they
become its visible soul.

JEAN COCTEAU

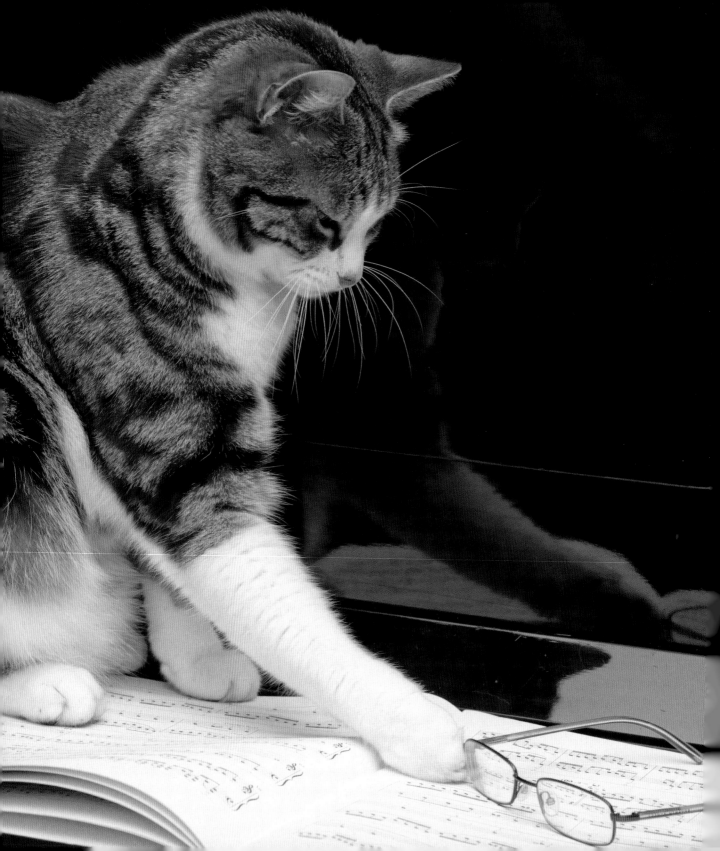

There are two means of
refuge from the miseries of life:
music and cats.

ALBERT SCHWEITZER

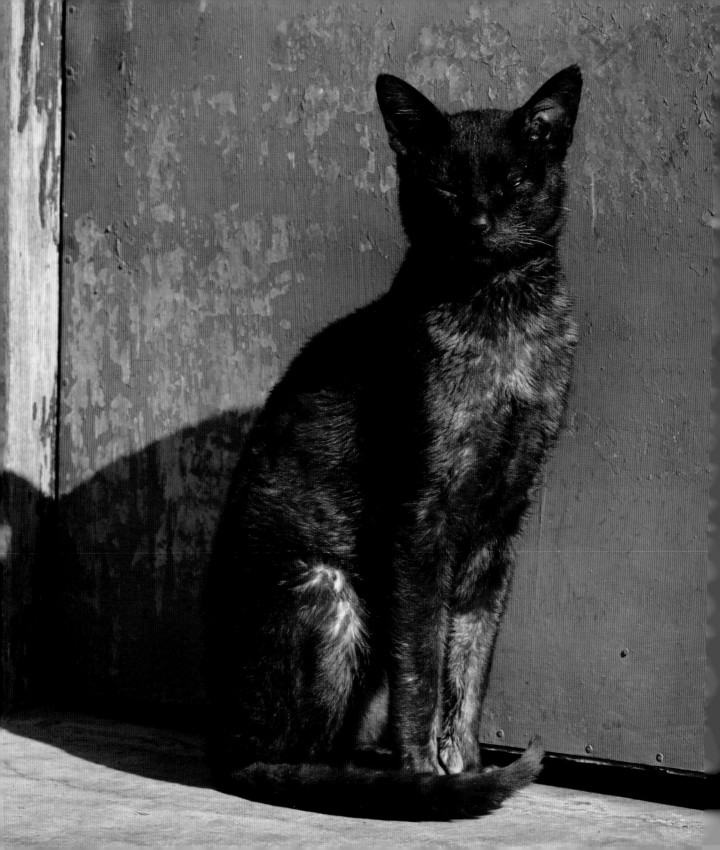

The ideal of calm exists in a sitting cat.

JULES REYNARD

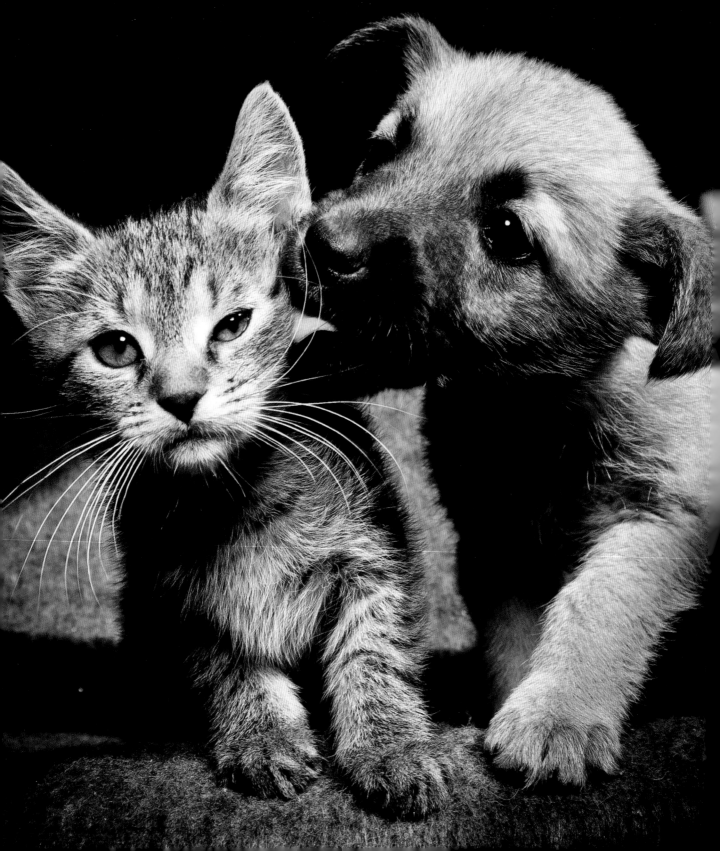

A dog will flatter you,
but you have to flatter the cat.

GEORGE MIKES

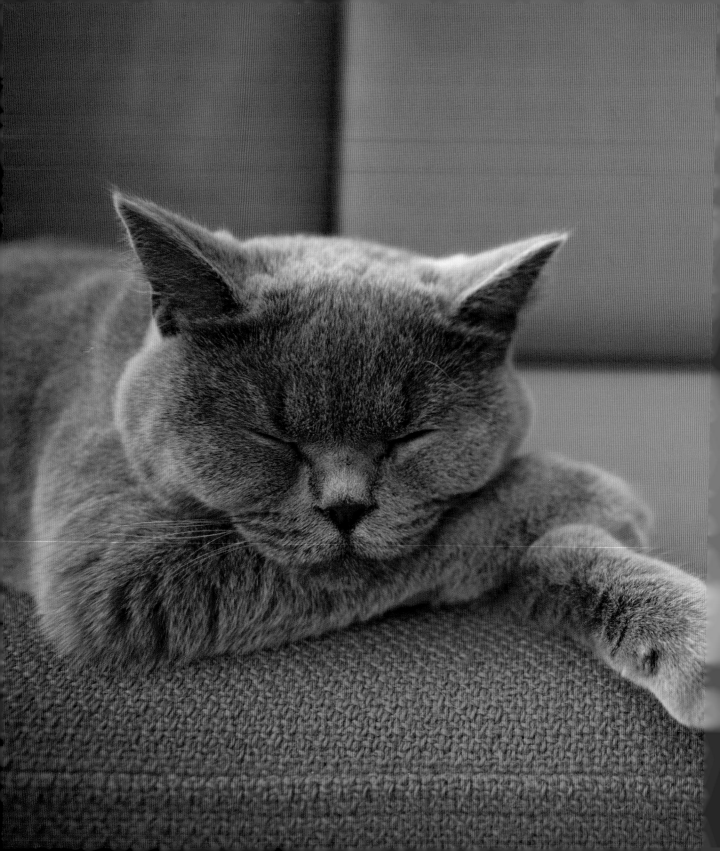

No amount of time can erase the
memory of a good cat, and no amount
of masking tape can ever totally
remove his fur from your couch.

LEO DWORKEN

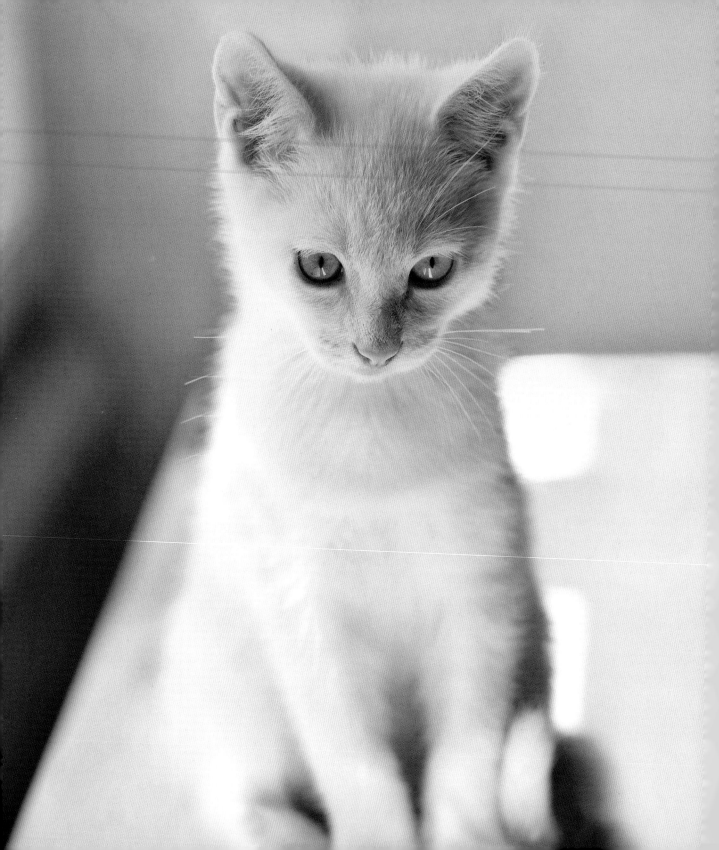

Like a graceful vase,
a cat, even when motionless,
seems to flow.

GEORGE F. WILL

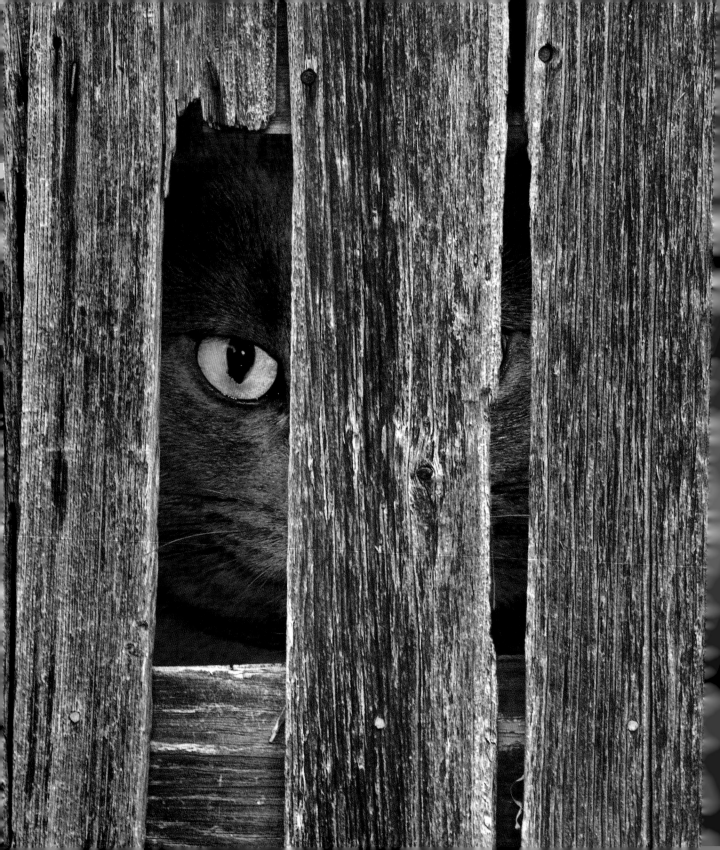

The mathematical probability
of a common cat doing exactly
as it pleases is the one scientific
absolute in the world.

LYNN M. OSBAND

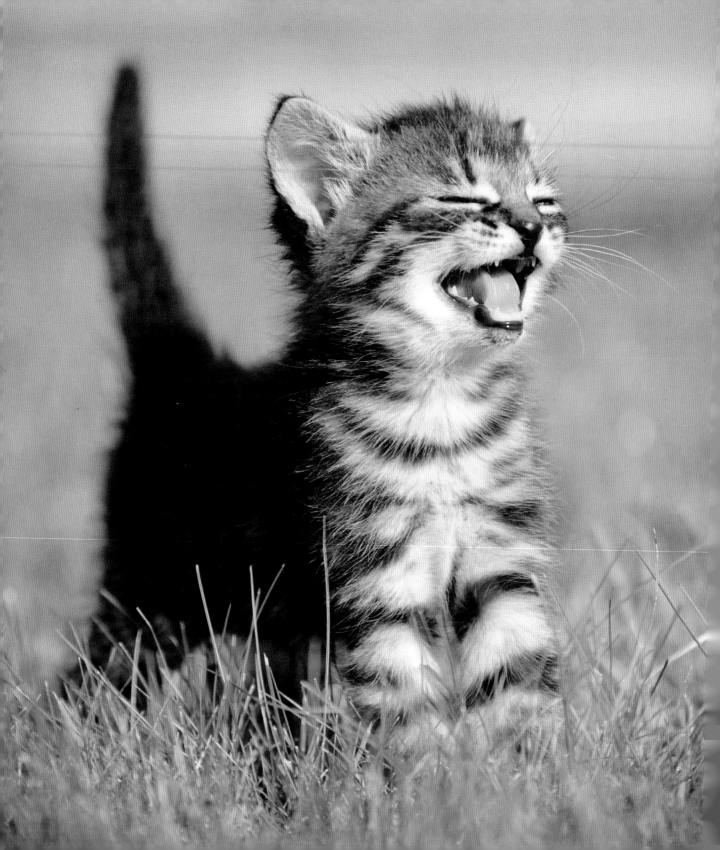

A meow massages the heart.

STUART MCMILLAN

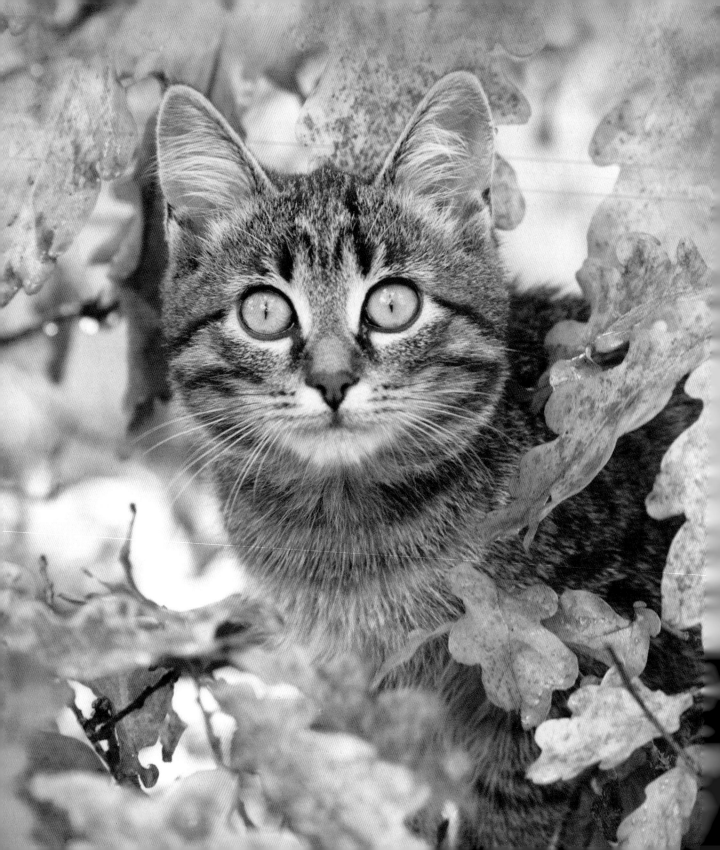

Prowling his own quiet backyard
or asleep by the fire, he is still only
a whisker away from the wilds.

JEAN BURDEN

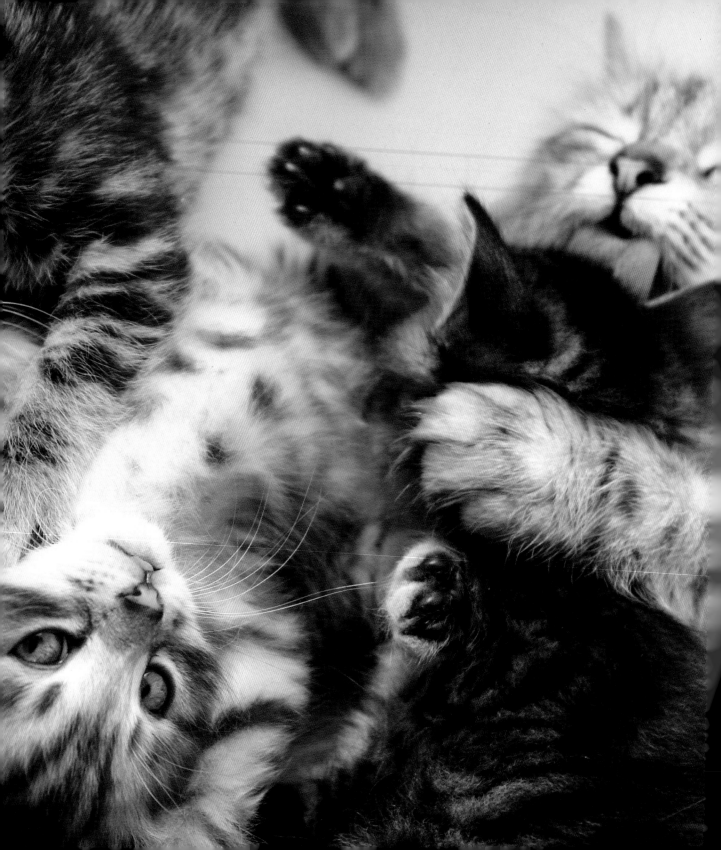

Most beds sleep up to six cats.
Ten cats without the owner.

STEPHEN BAKER

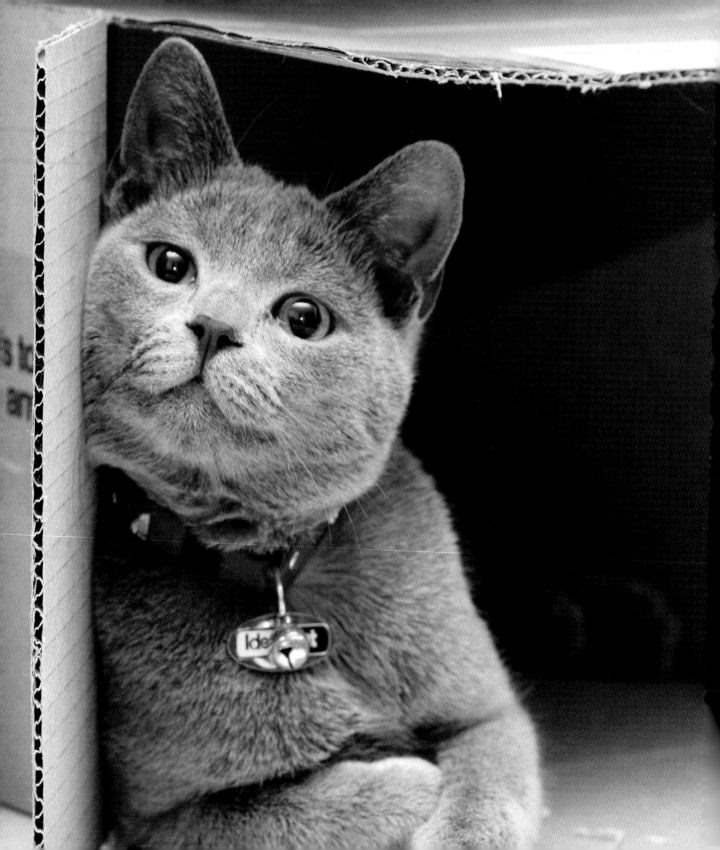

Cats are a mysterious kind of folk. There is more passing in their minds than we are aware of.

SIR WALTER SCOTT

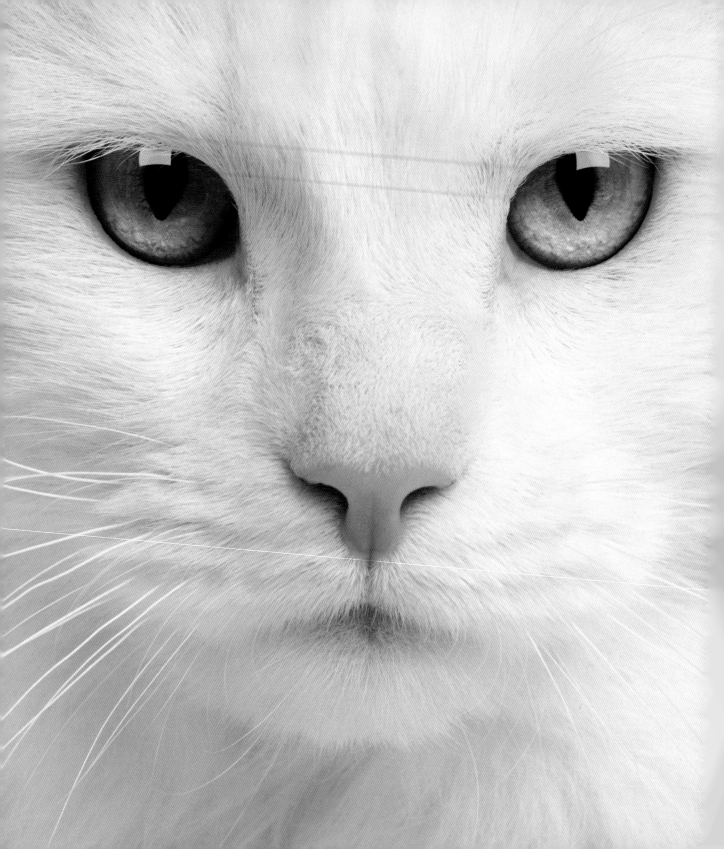

I believe cats to be spirits come to earth. A cat, I am sure, could walk on a cloud without coming through.

JULES VERNE

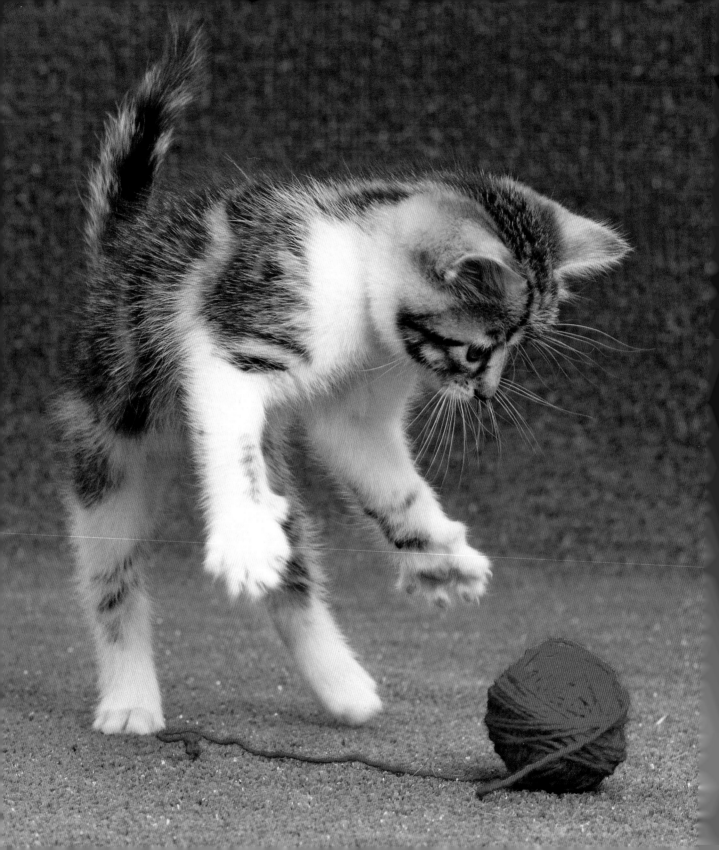

Cats do not have to be shown how to have a good time, for they are unfailing ingenious in that respect.

JAMES MASON

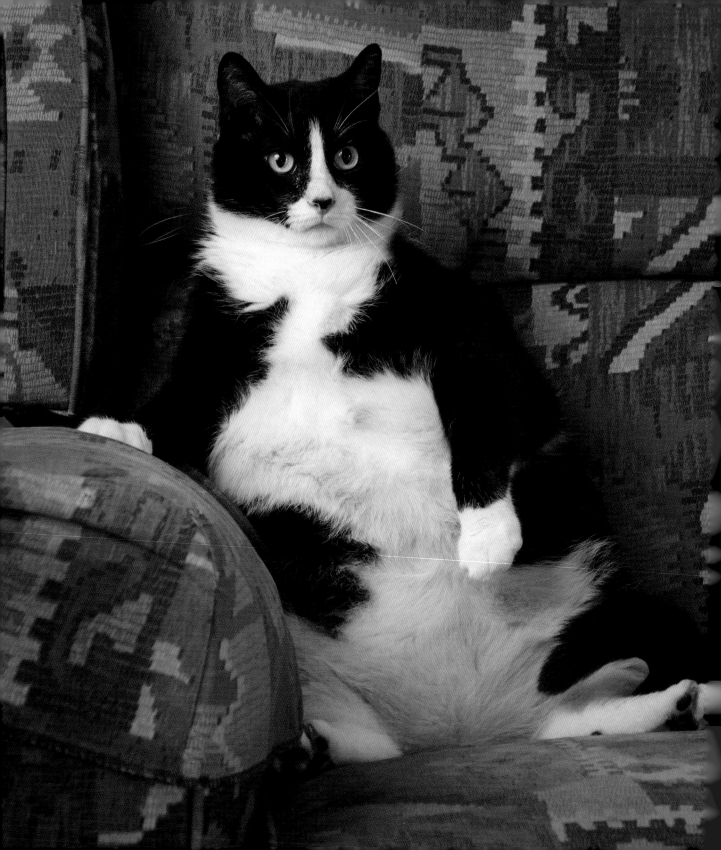

Even overweight, cats instinctively know the cardinal rule: when fat, arrange yourself in slim poses.

JOHN WEITZ

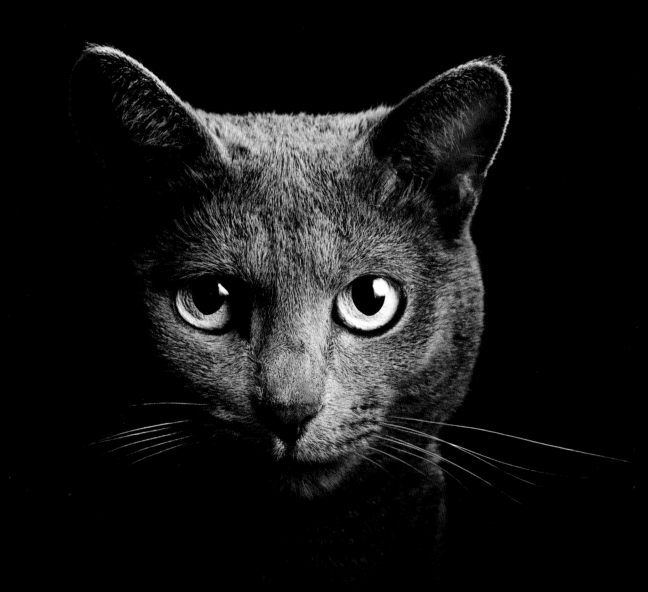

Of all God's creatures, there is only
one that cannot be made slave of
the lash. That one is the cat.
If man could be crossed with the
cat it would improve the man, but
it would deteriorate the cat.

MARK TWAIN

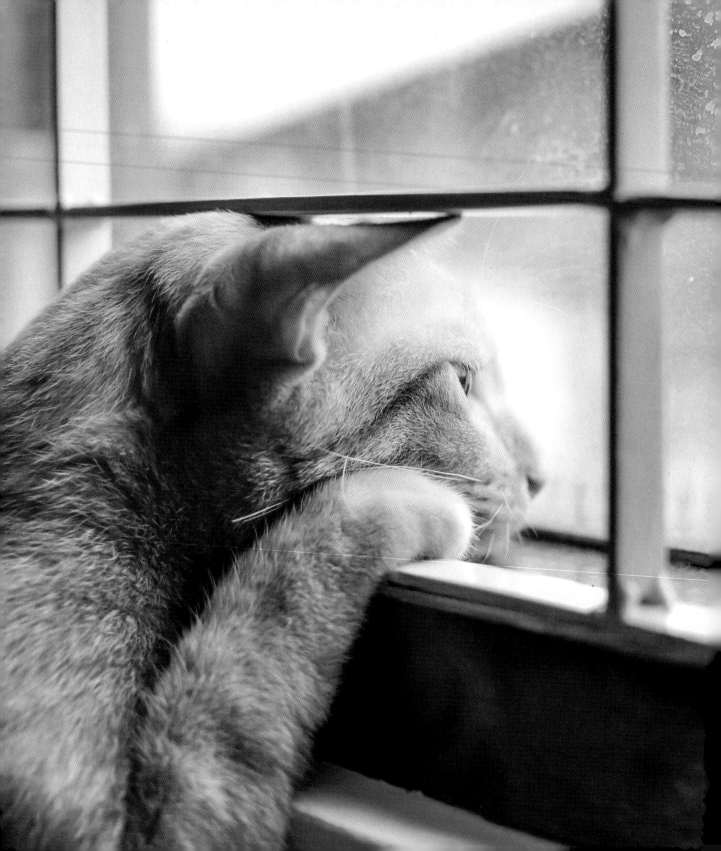

Dogs come when they're called; cats take a message and get back to you later.

MARY BLY

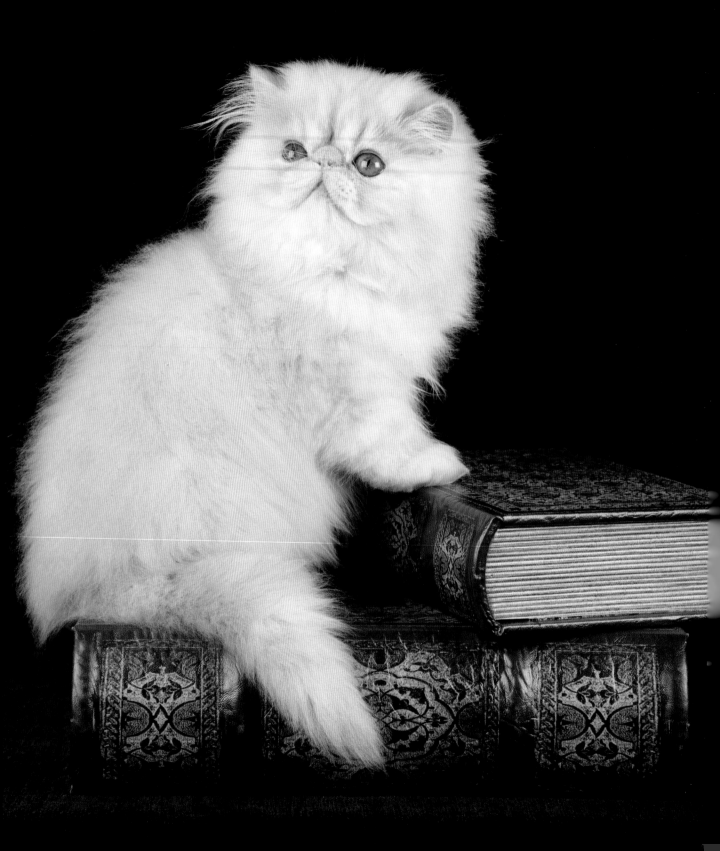

I have studied many philosophers
and many cats. The wisdom of cats
is infinitely superior.

HIPPOLYTE TAINE

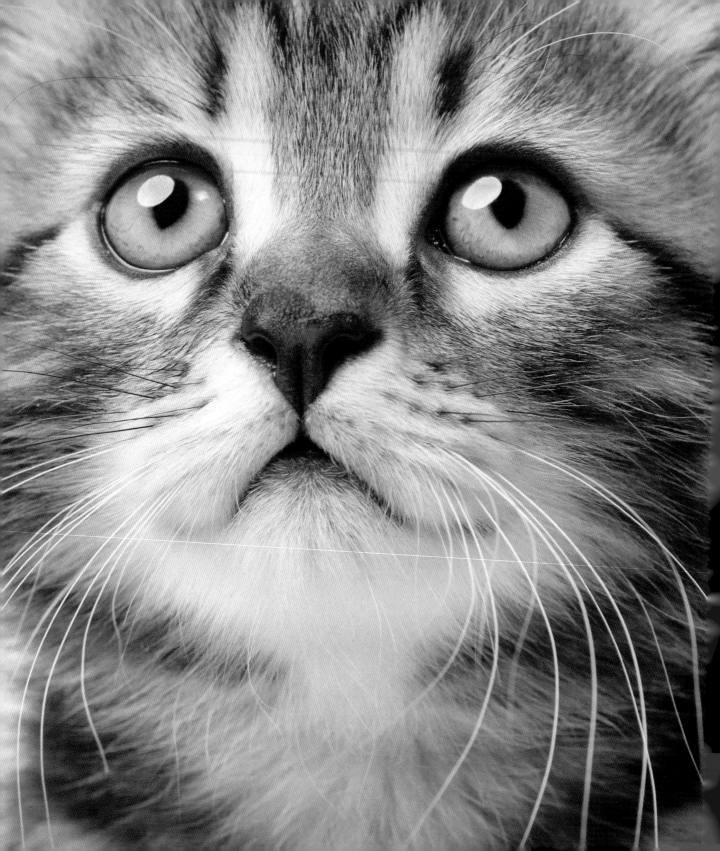

If he is comic, it is only because
of the incongruity of so demure
a look and so wild a heart.

ALAN DEVOE

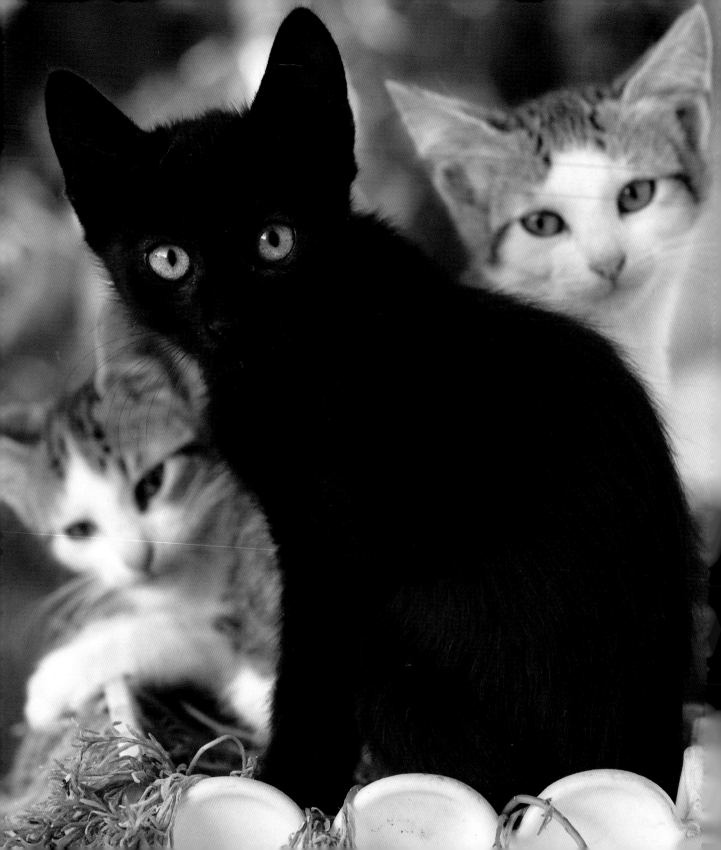

God is really only another
artist. He invented the giraffe,
the elephant and the cat. He
has no real style. He just goes
on trying other things.

PABLO PICASSO

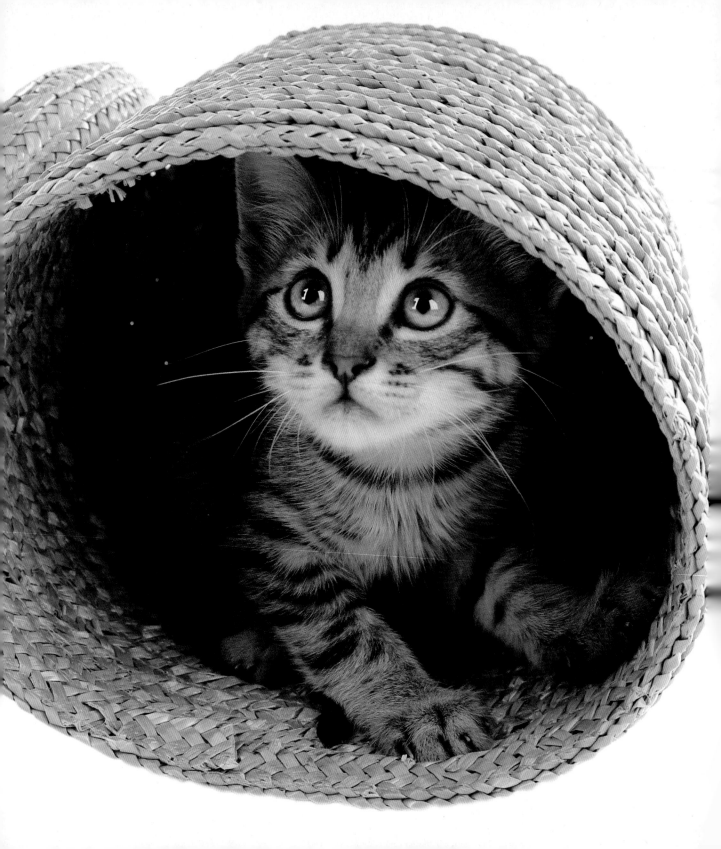

When I play with my cat,
how do I know that she is
not passing time with me
rather than I with her?

MONTAIGNE

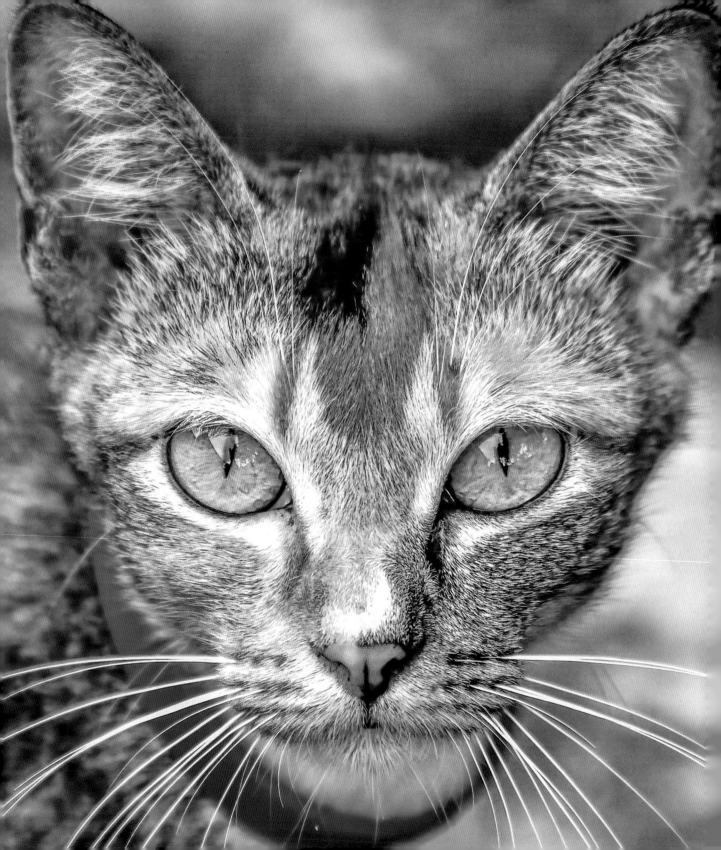

A cat is a tiger that is fed by hand.

UNKNOWN

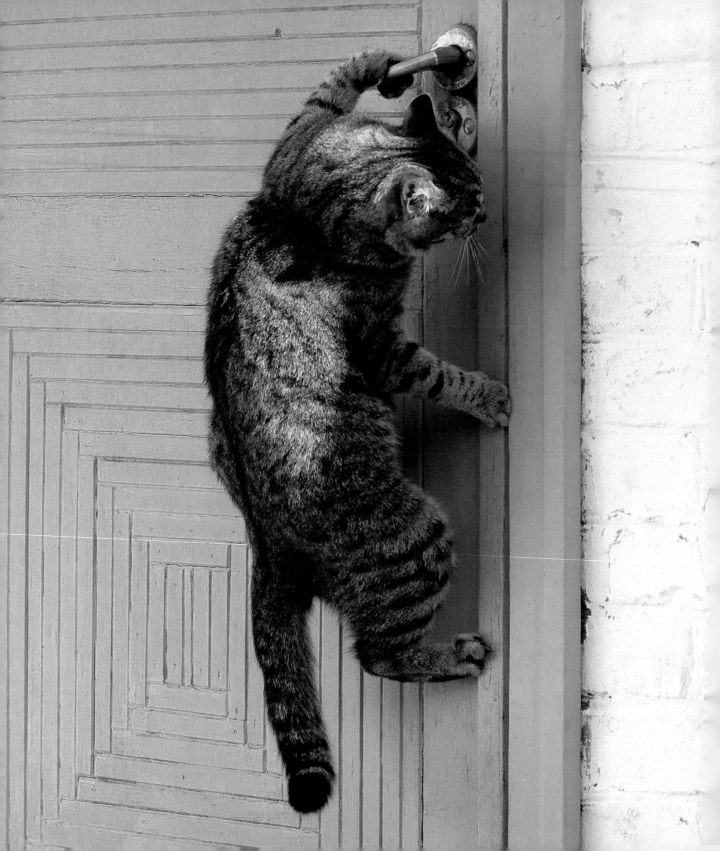

Most cats, when they are Out
want to be In, and vice versa, and
often simultaneously.

LOUIS J. CAMUTI

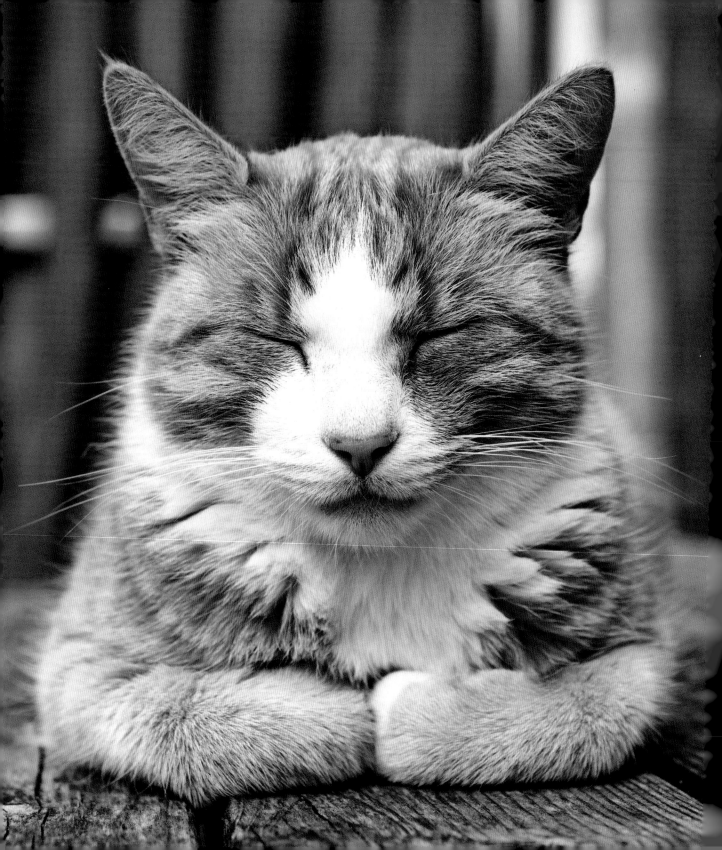

If we treated everyone we met
with the same affection we
bestow upon our favourite cat,
they, too, would purr.

MARTIN BUXBAUM

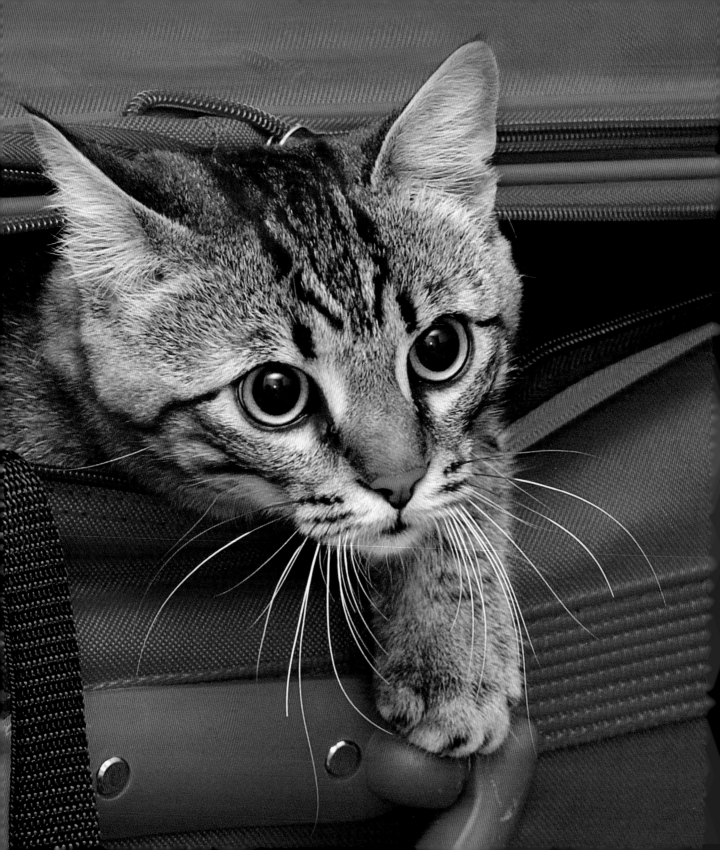

There are no ordinary cats.

COLETTE

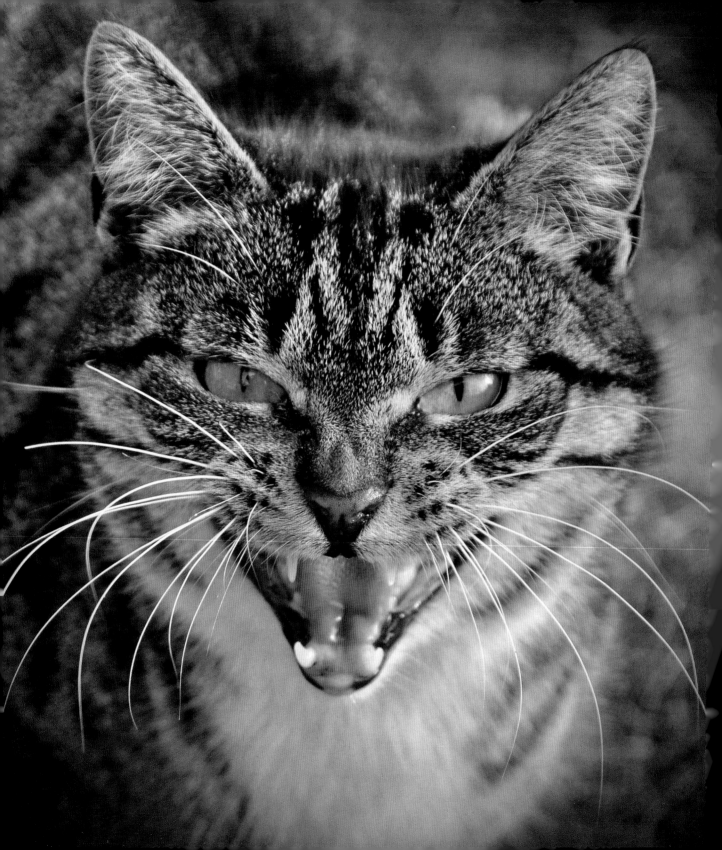

A cat has absolute emotional honesty: human beings, for one reason or another, may hide their feelings, but a cat does not.

ERNEST HEMINGWAY

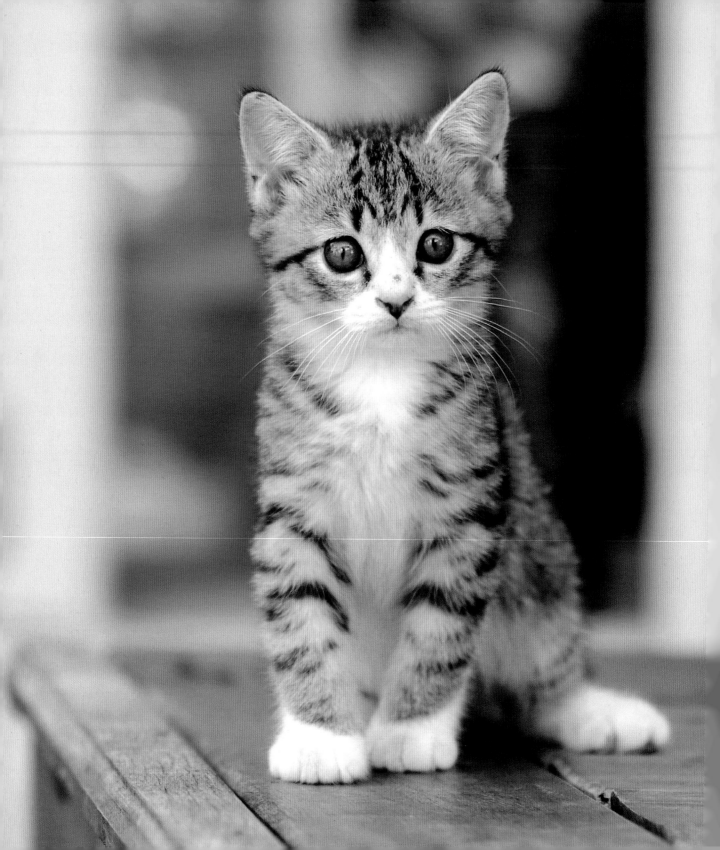

The smallest feline is a masterpiece.

LEONARDO DA VINCI

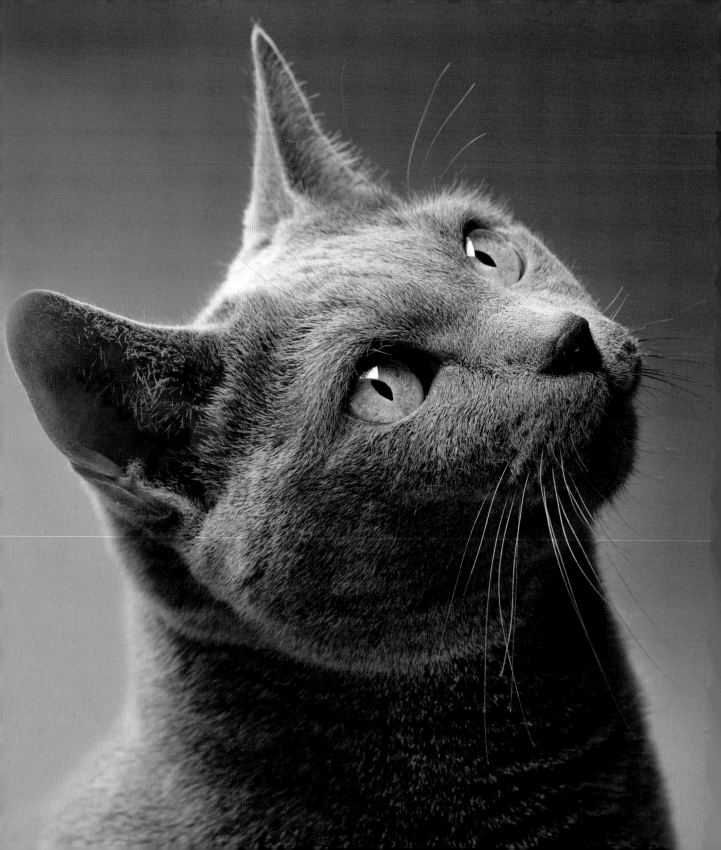

What greater gift than the love of a cat?

CHARLES DICKENS

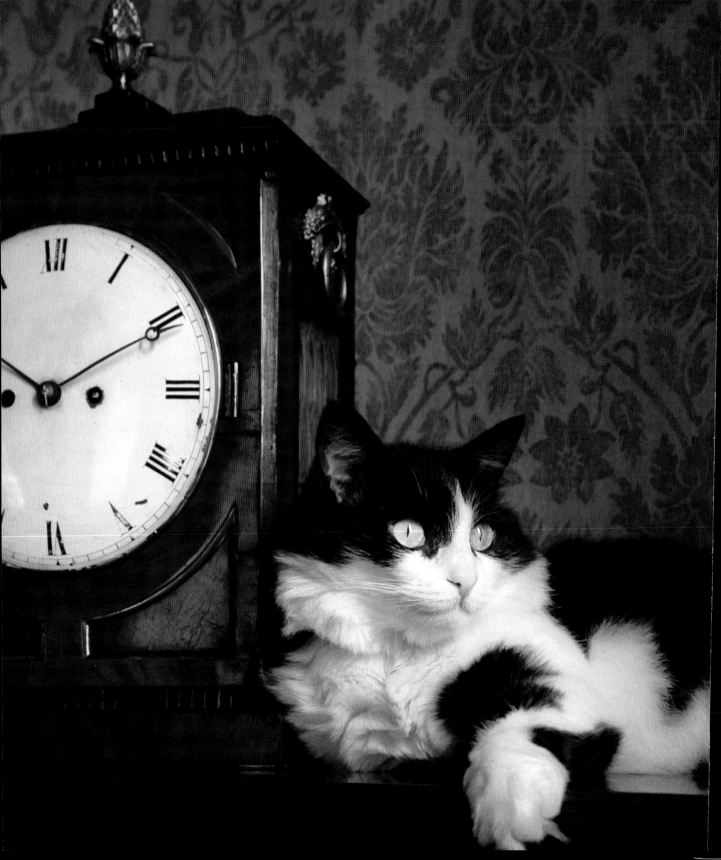

Two things are aesthetically perfect in the world — the clock and the cat.

EMILE AUGUSTE CHARTIER

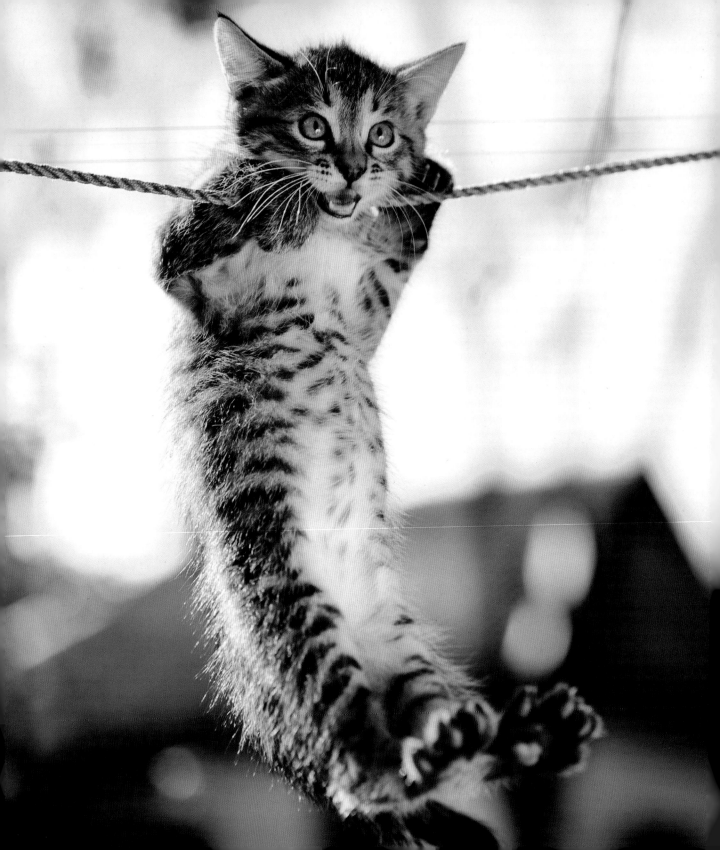

There is no more intrepid
explorer than a kitten.

JULES CHAMPFLEURY

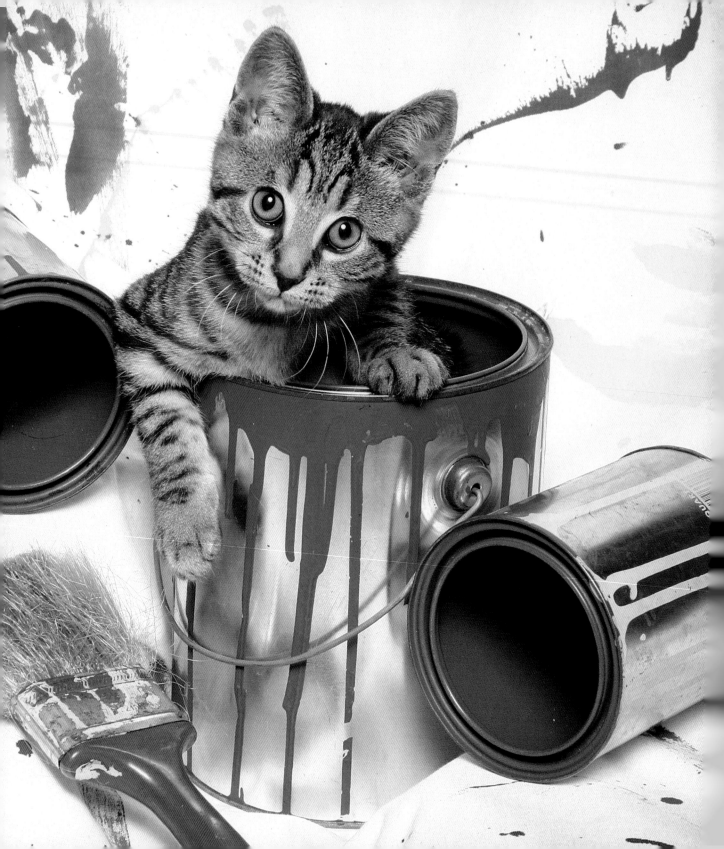

Because of our willingness
to accept cats as superhuman
creatures, they are the ideal animals
with which to work creatively.

RONI SCHOTTER

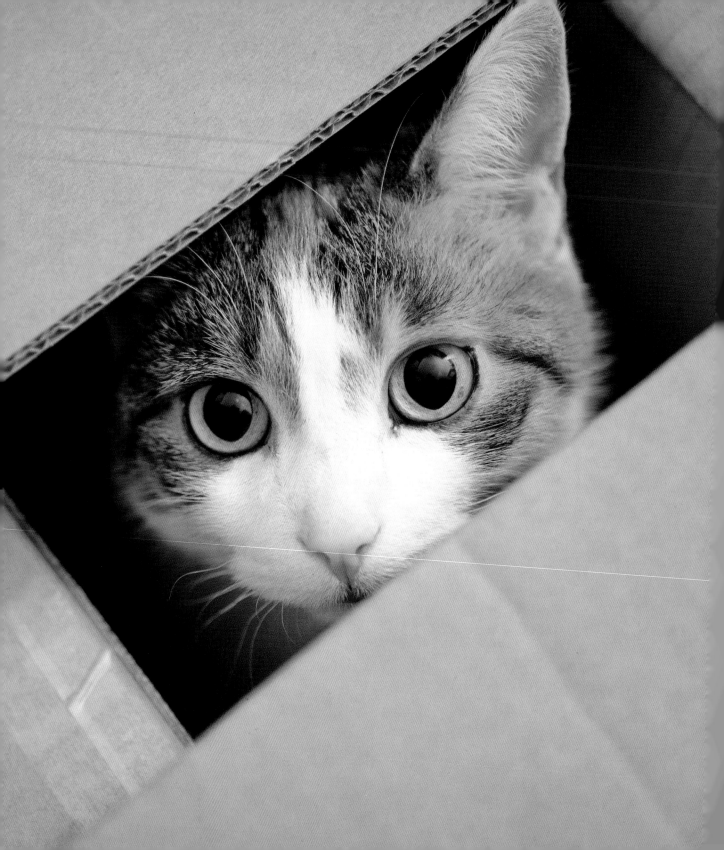

The cat has too much spirit
to have no heart.

ERNEST MENAUL

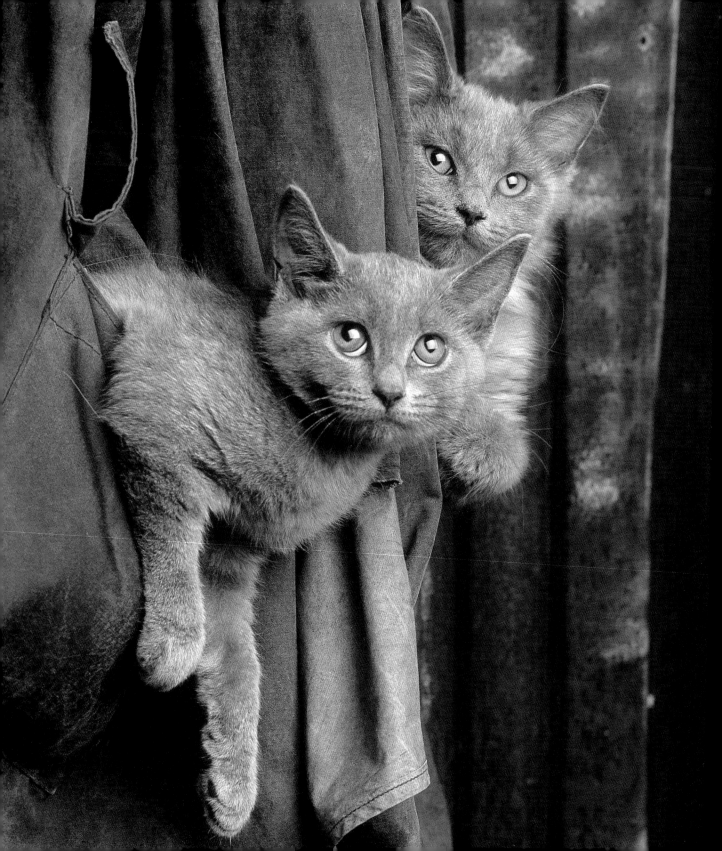

Some people own cats and go
on to lead normal lives.

UNKNOWN

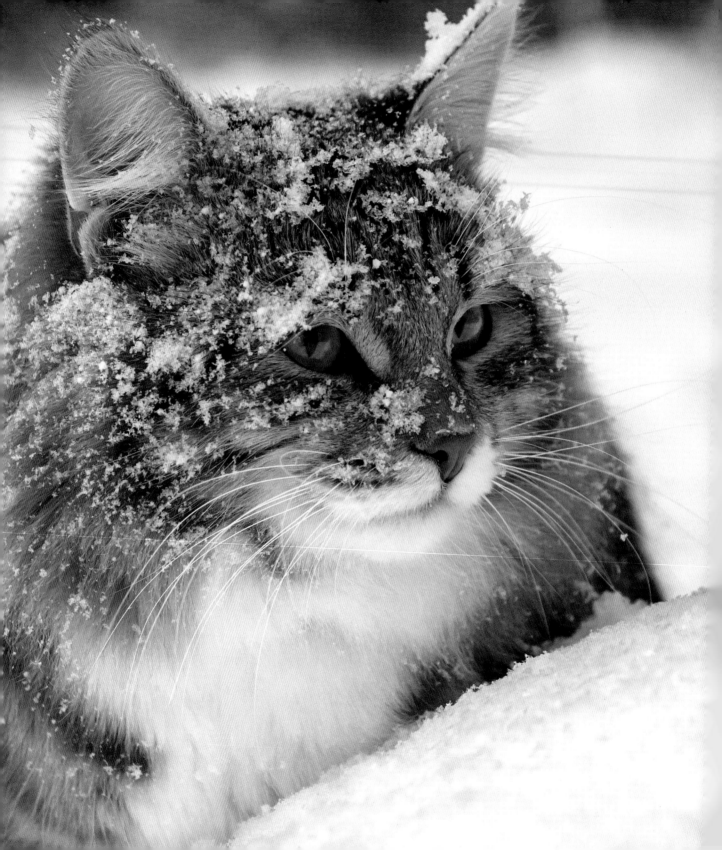

The phrase 'domestic cat'
is an oxymoron.

GEORGE F. WILL

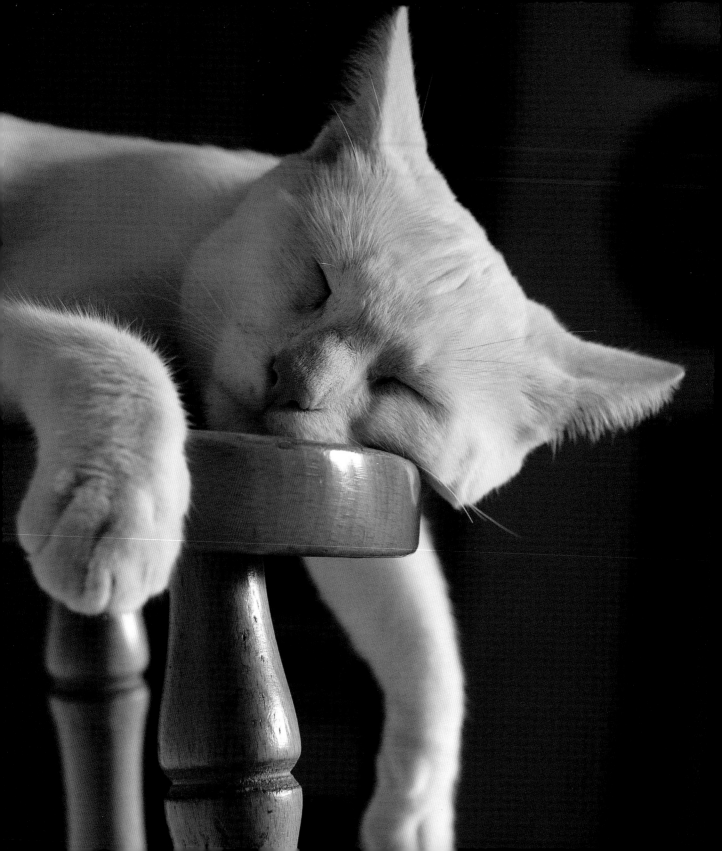

You cannot look at a sleeping cat
and feel tense.

JANE PAULEY

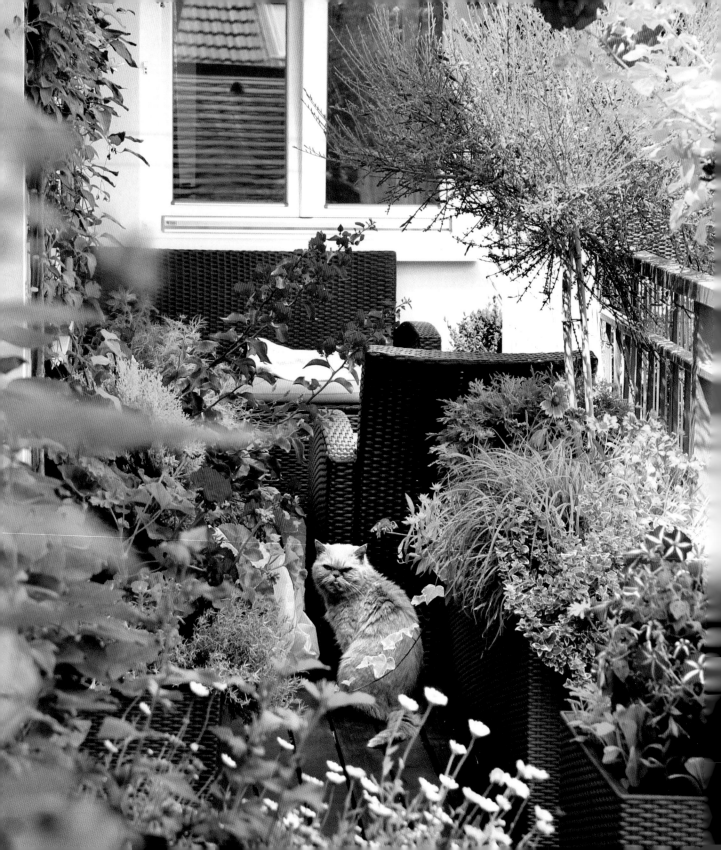

Civilisation is defined by
the presence of cats.

UNKNOWN

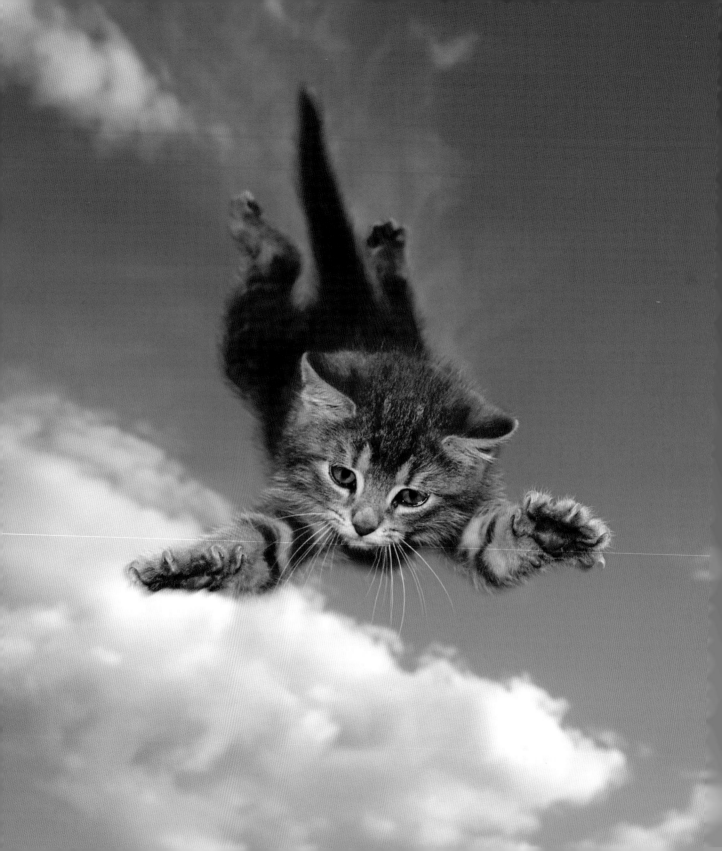

One of the most striking
differences between a cat
and a lie is that a cat has
only nine lives.

MARK TWAIN

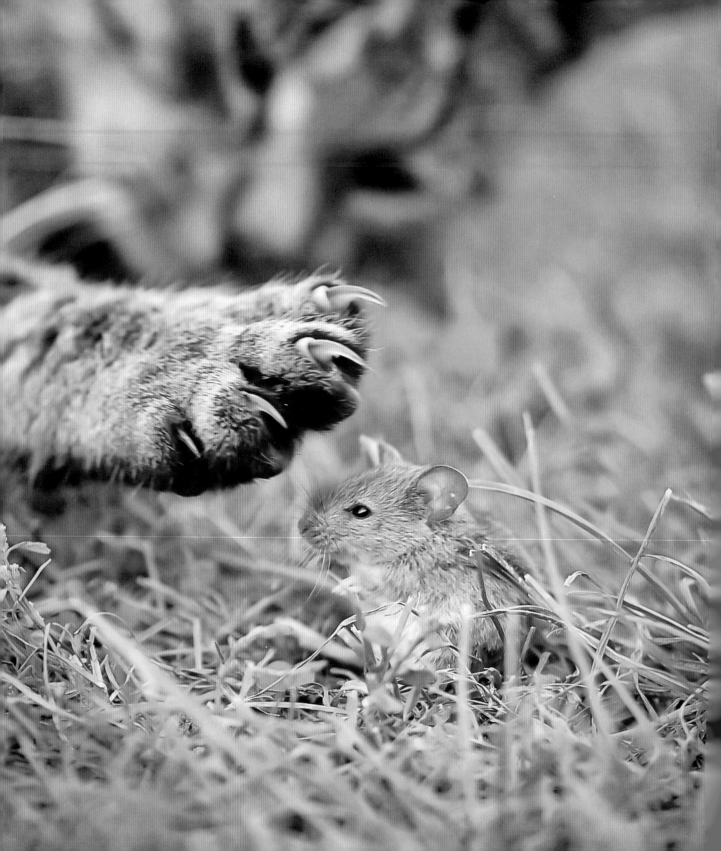

The cat does not negotiate
with the mouse.

ROBERT K. MASSIE

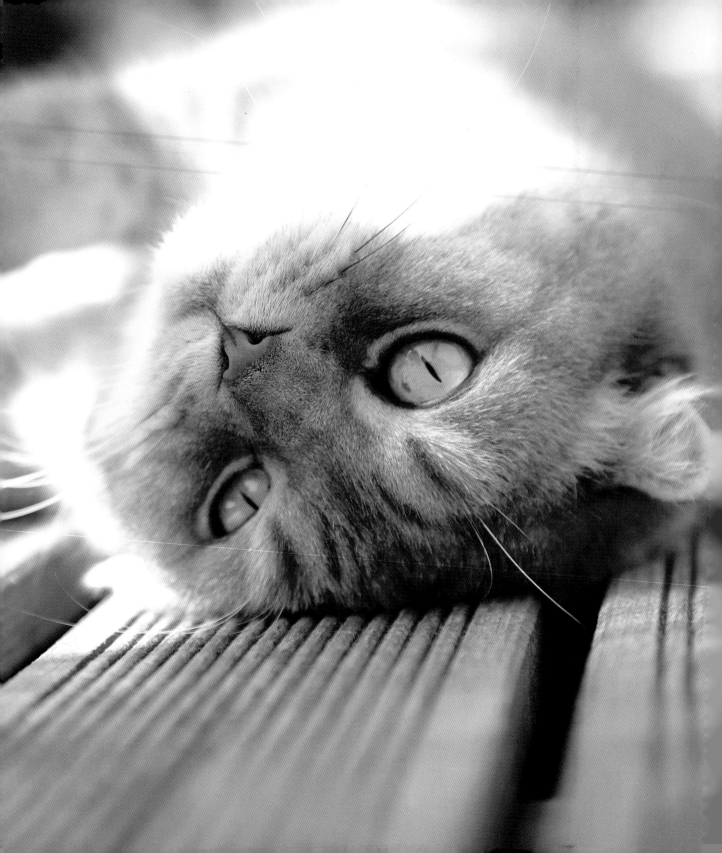

If there is one spot of sun
spilling onto the floor, a cat
will find it and soak it up.

JOAN ASPER MCINTOSH

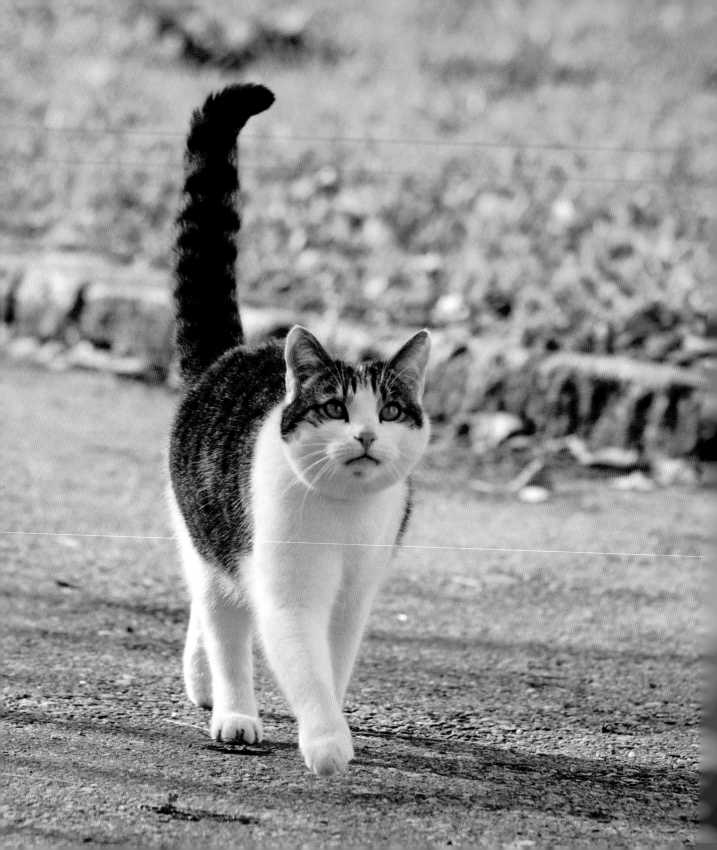

In the middle of a world that
has always been a bit mad, the
cat walks with confidence.

ROSANNE AMBERSON

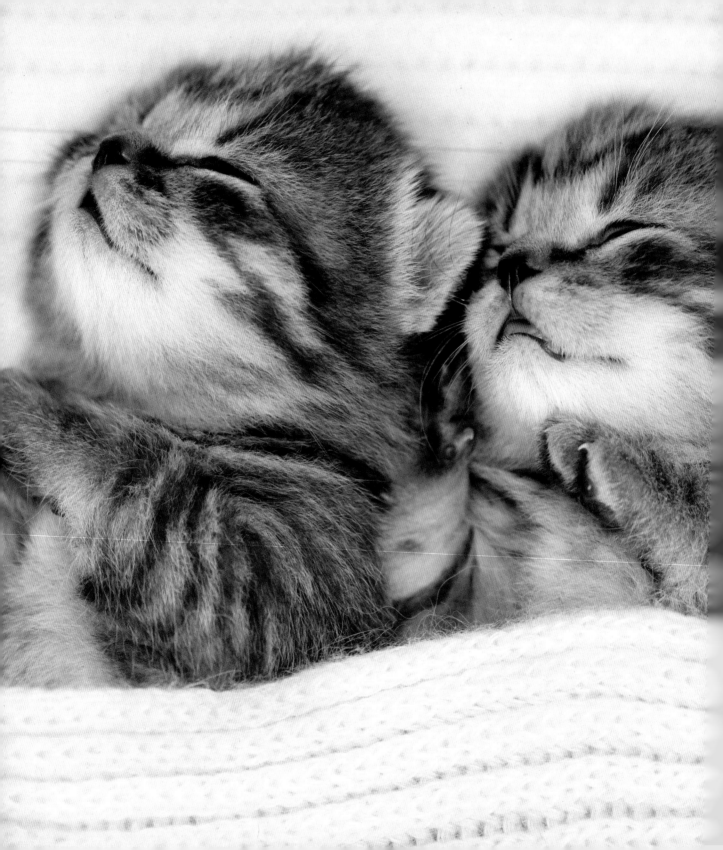

Kittens are born with their eyes shut. They open them in about six days, take a look around, then close them again for the better part of their lives.

STEPHEN BAKER

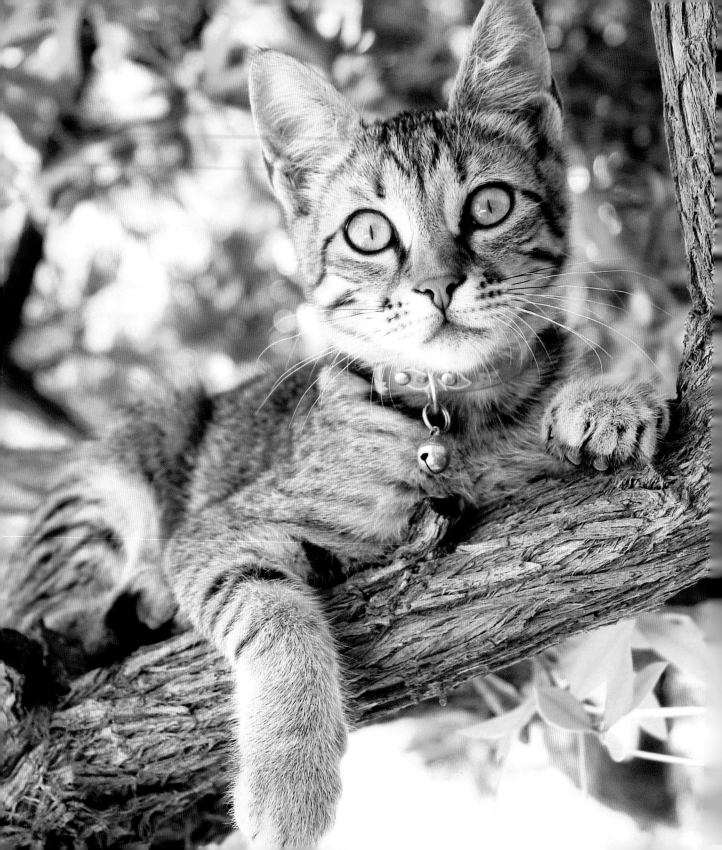

The reason cats climb is so that they can look down on almost every other animal ... it's also the reason they hate birds.

K.C. BUFFINGTON

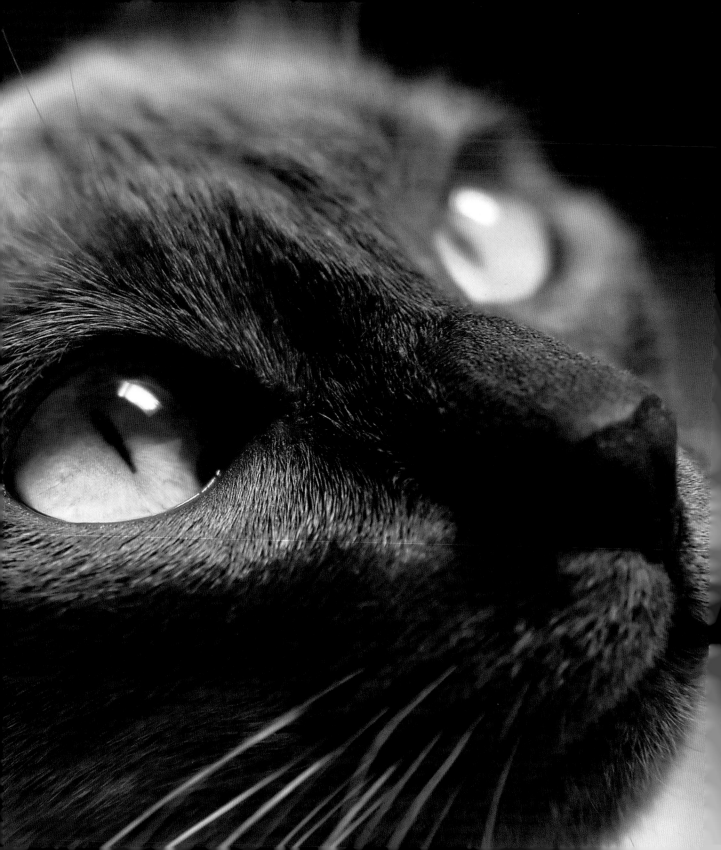

It always gives me a
shiver when I see a cat
seeing what I can't see.

ELEANOR FARJEON

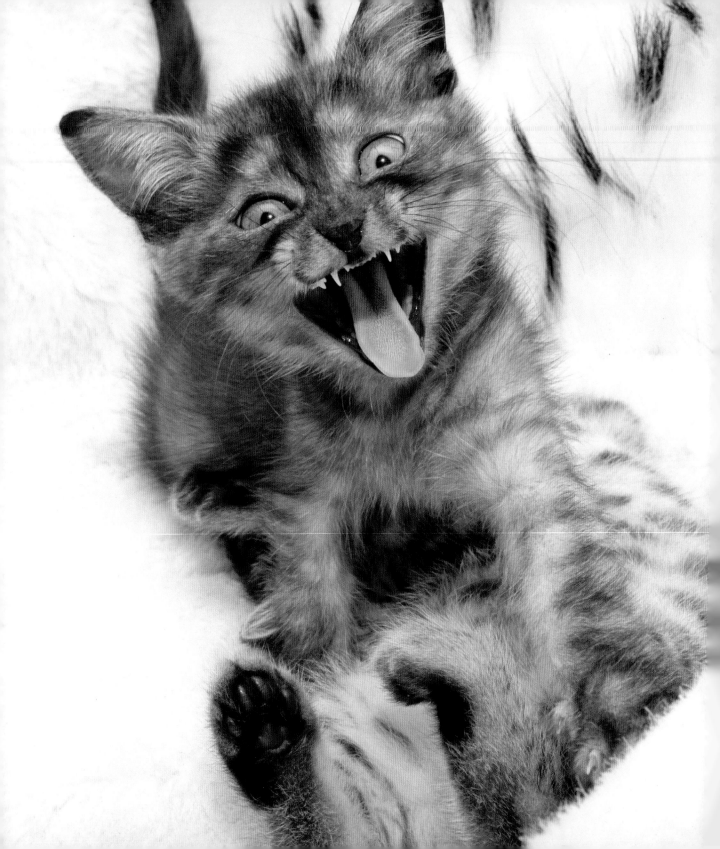

Of all domestic animals, the cat is the most expressive. His face is capable of showing a wide range of expressions. His tail is a mirror of his mind. His gracefulness is surpassed only by his agility. And, along with all these, he has a sense of humour.

WALTER CHANDOHA

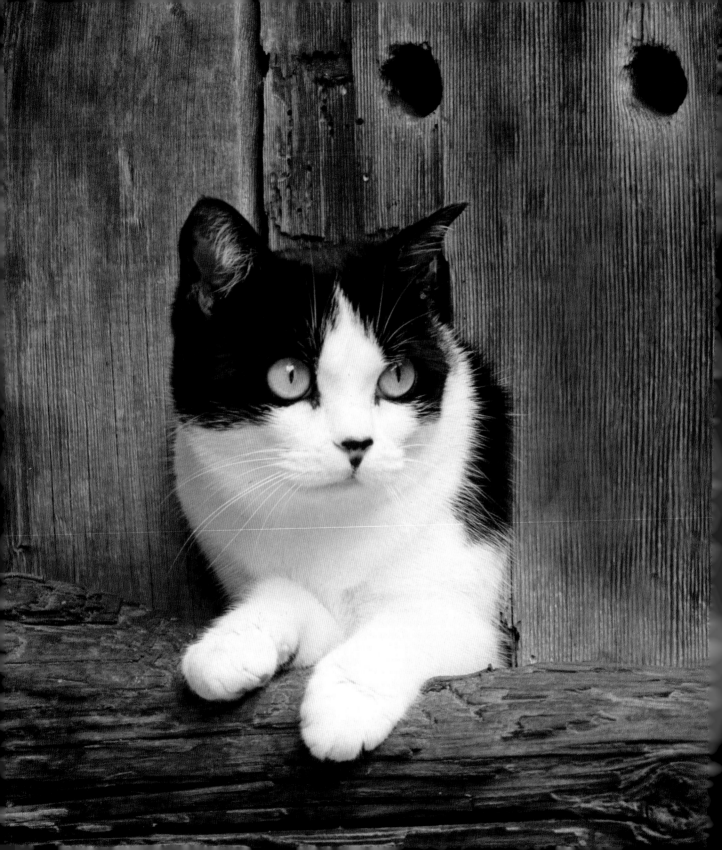

Cats, no less liquid than their shadows, offer no angles to the wind. They slip, diminished, neat, through loopholes less than themselves.

A.S.J. TESSIMOND

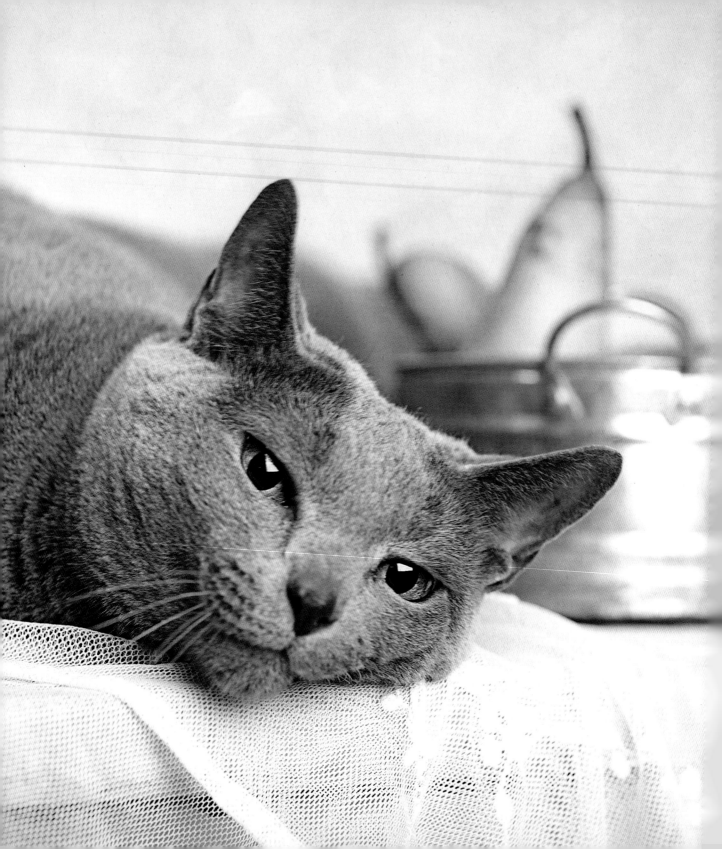

Cats can work out mathematically
the exact place to sit that will
cause most inconvenience.

PAM BROWN

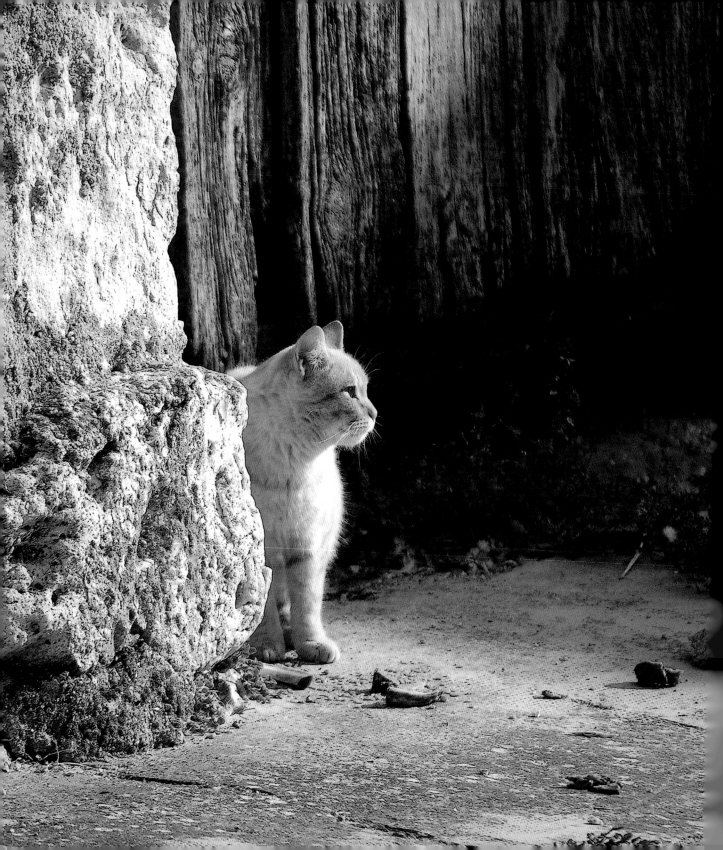

Some animals are secretive;
some are shy. A cat is private.

LEONARD MICHAELS

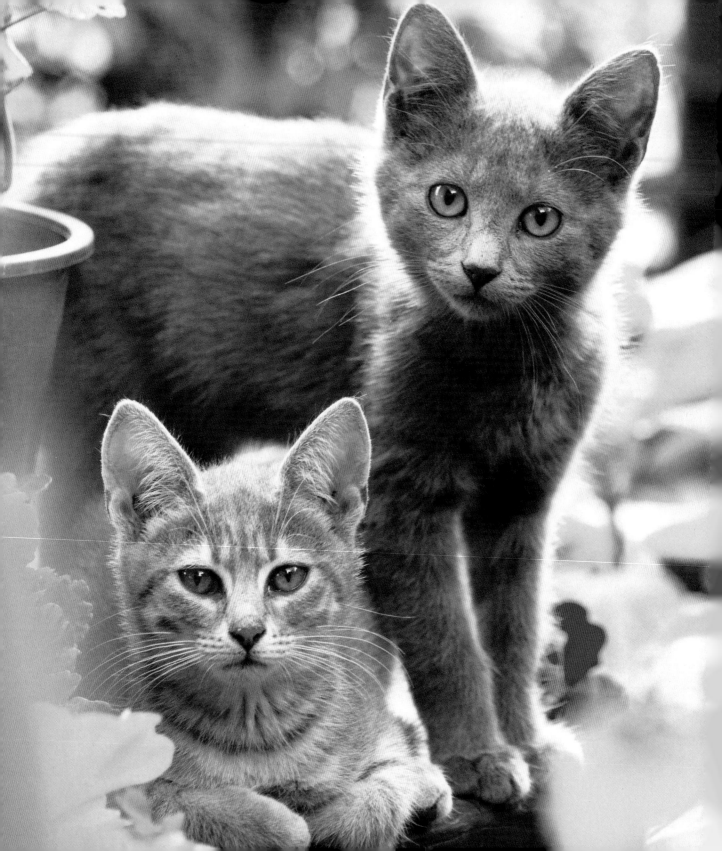

A cat is there when you call her — if she doesn't have something better to do.

BILL ADLER

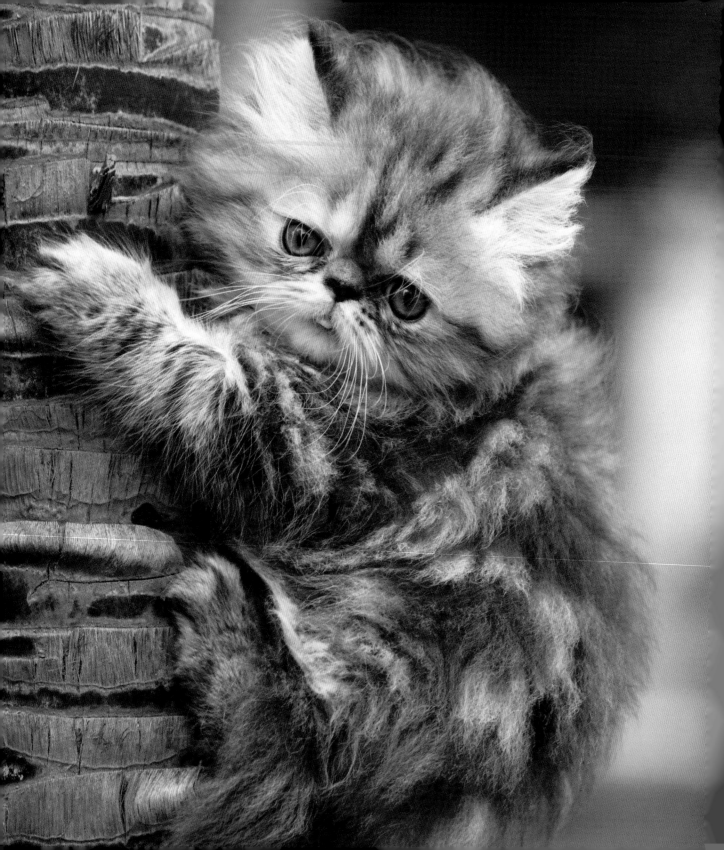

If the claws didn't retract,
cats would be like Velcro.

DR BRUCE FOGLE

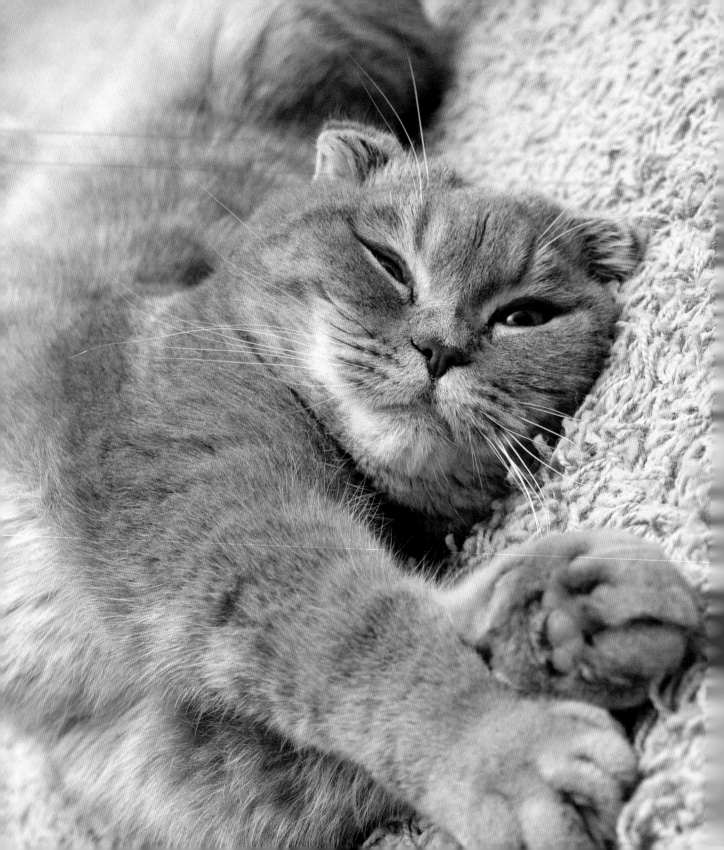

If stretching were wealth,
the cat would be rich.

AFRICAN PROVERB

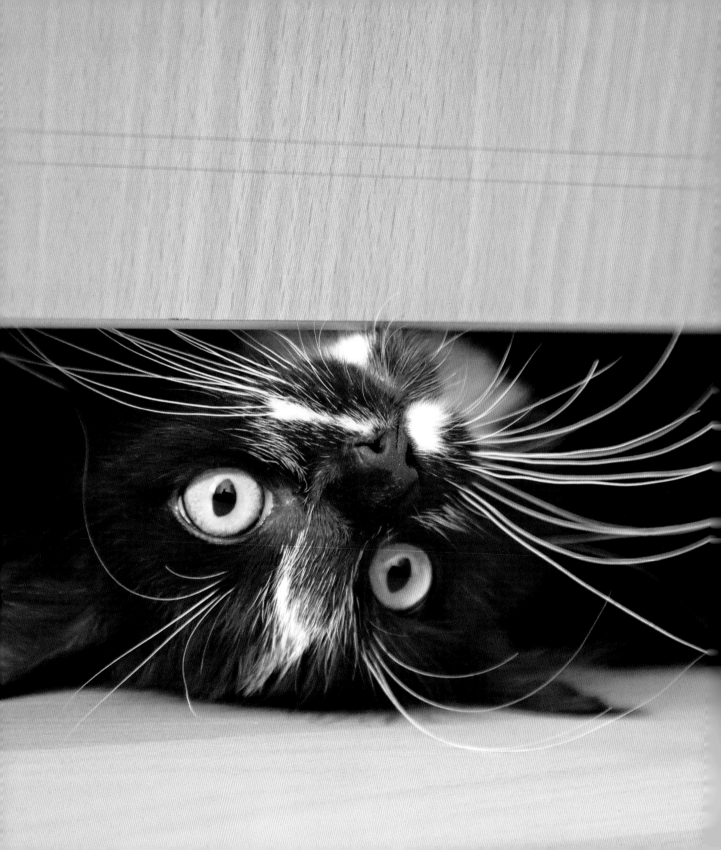

Places to look: behind the books in the bookshelf, any cupboard with a gap too small for any cat to squeeze through, the top of anything sheer, under anything too low for a cat to squash under, and inside the piano.

ROSEANNE AMBROSE-BROWN

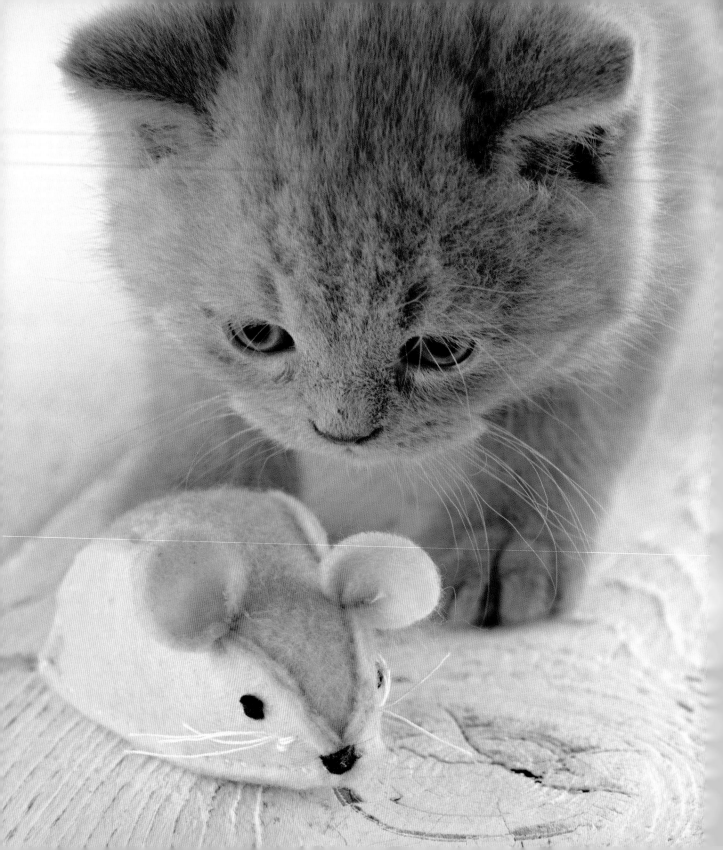

Any cat who misses a mouse pretends
it was aiming for the dead leaf.

CHARLOTTE GRAY

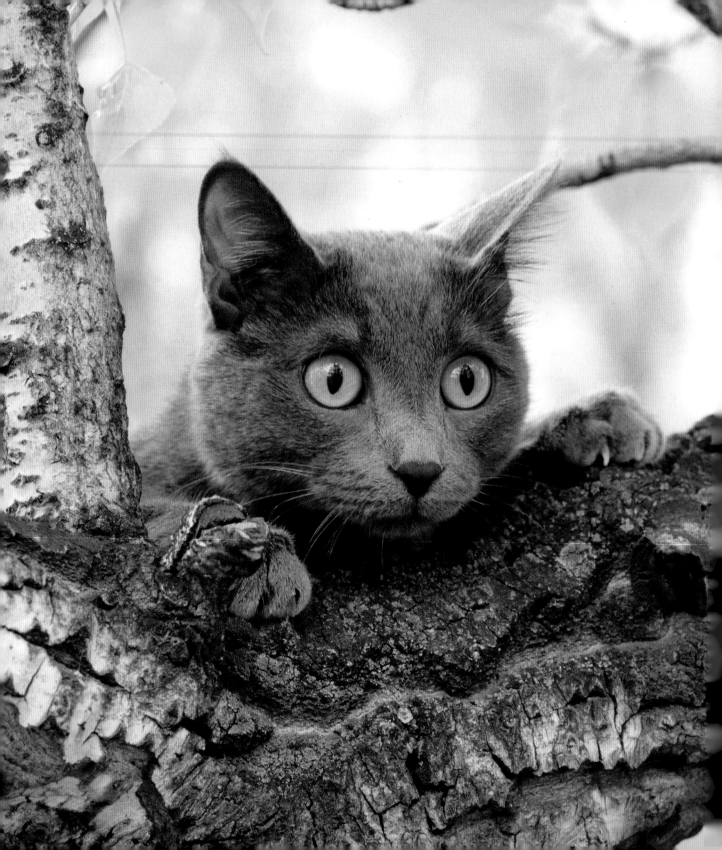

If your cat falls out of a tree,
go indoors to laugh.

PATRICIA HITCHCOCK

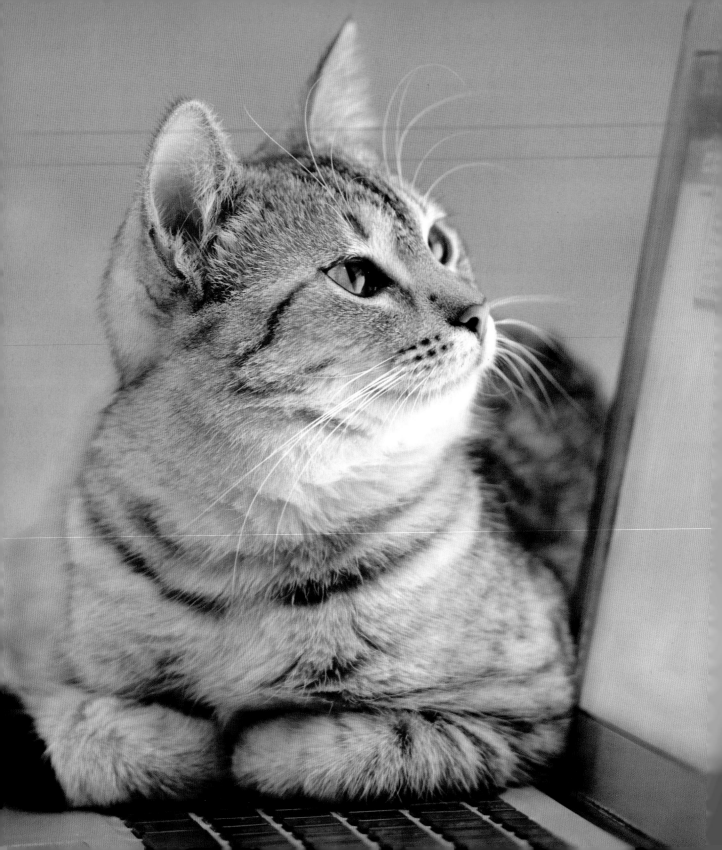

Cats are dangerous companions
for writers because cat watching
is a near-perfect method of
writing avoidance.

DAN GREENBURG

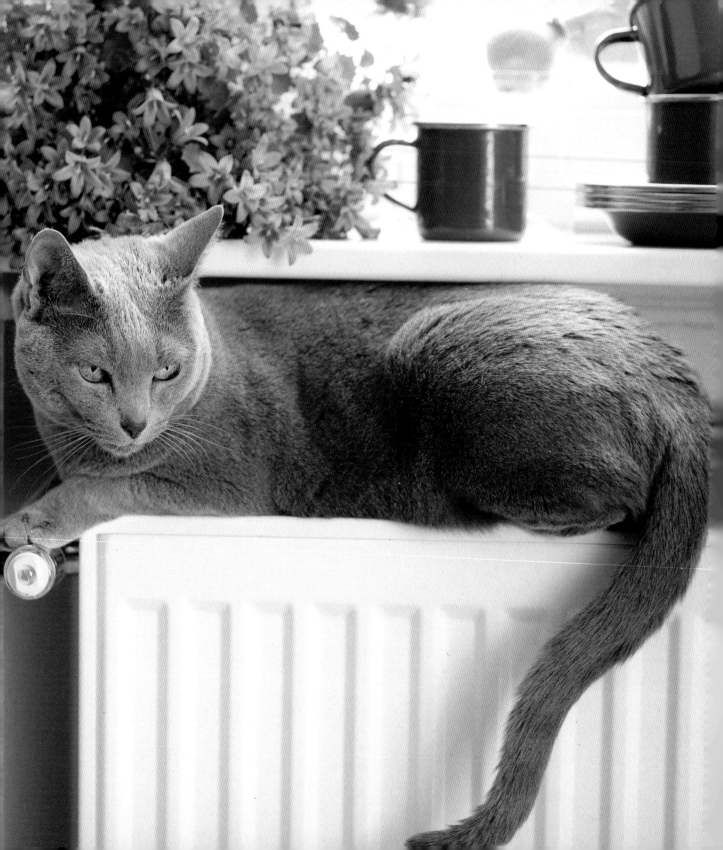

To some blind souls all cats are much alike. To a cat lover, every cat from the beginning of time has been utterly and amazingly unique.

JENNY DE VRIES

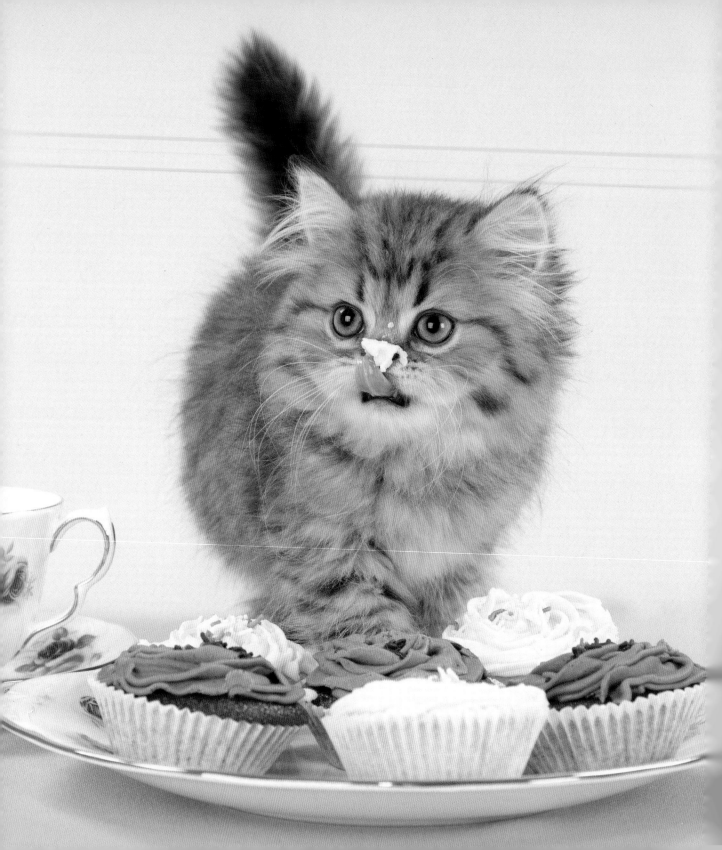

A cat isn't fussy — just so long as you remember he likes his milk in the shallow, rose-patterned saucer and his fish on the blue plate. From which he will take it, and eat it off the floor.

ARTHUR BRIDGES

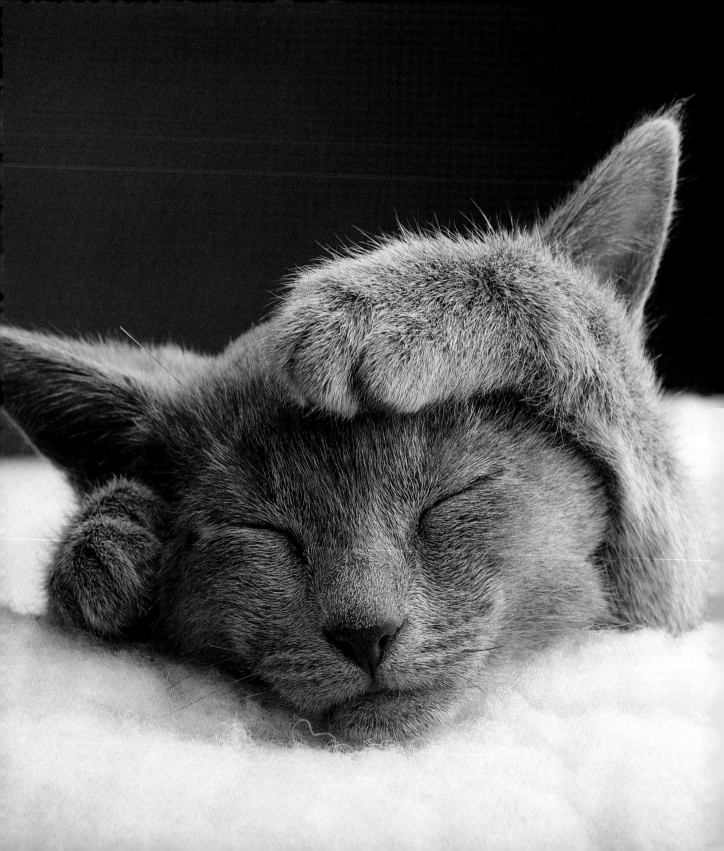

A cat can maintain a position of curled-up somnolence on your knee until you are nearly upright. To the last minute she hopes your conscience will get the better of you and you will settle down again.

PAM BROWN

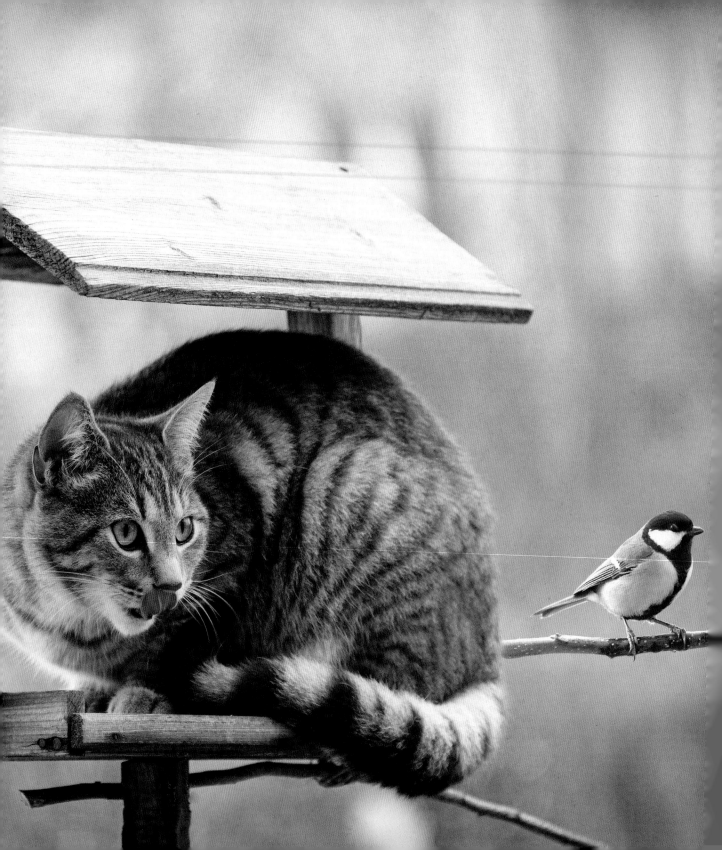

Cats too, with what silent
stealthiness,with what light steps
do they creep up to a bird!

PLINY THE ELDER

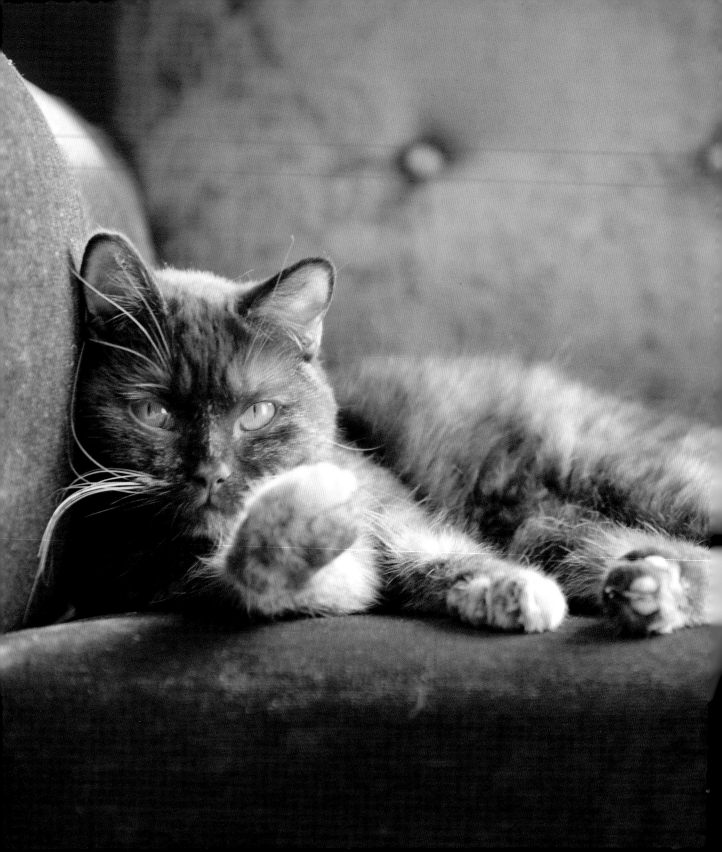

All cats love a cushioned couch.

THEOCRITUS

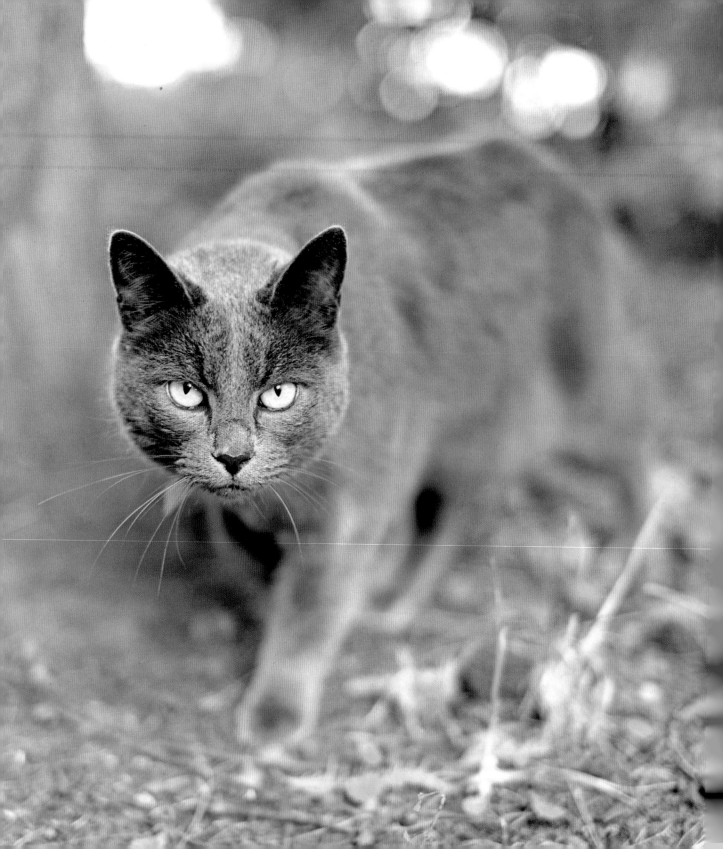

It is the nature of cats to
do a certain amount of
unescorted roaming.

ADLAI STEVENSON

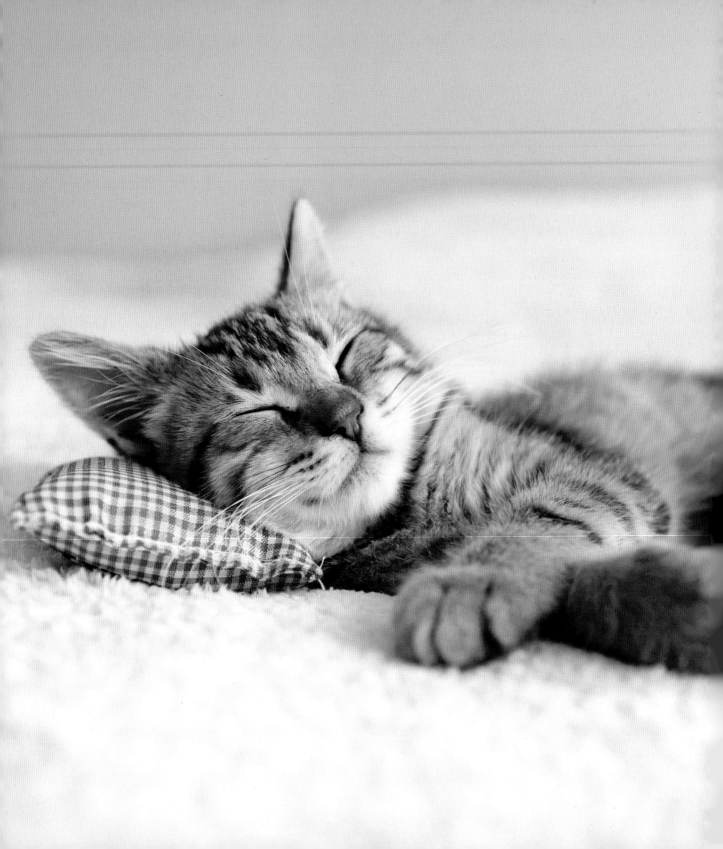

Cats are connoisseurs
of comfort.

JAMES HERRIOT

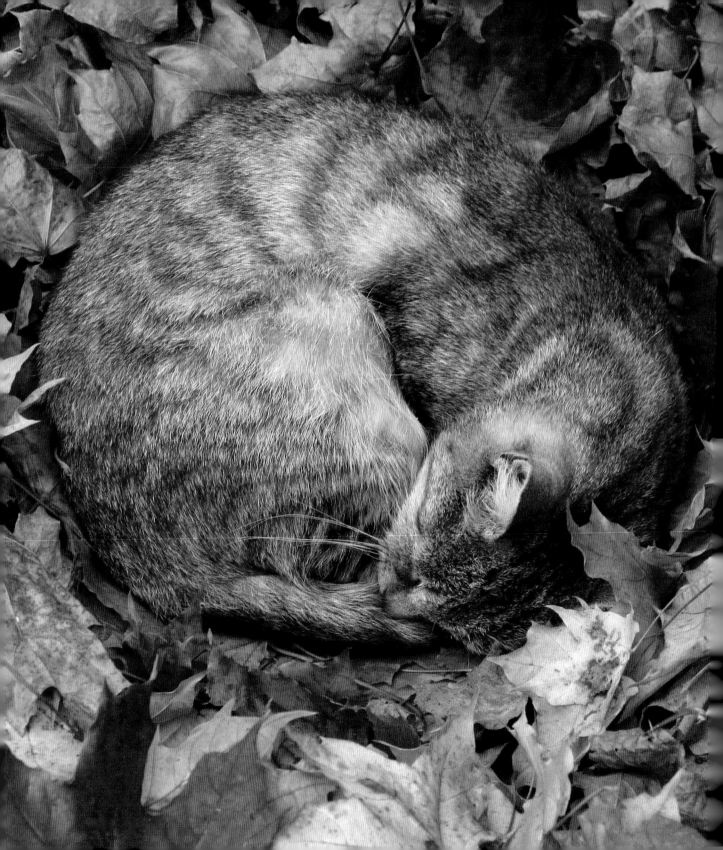

He seems the incarnation of everything
soft and silky and velvety, without a
sharp edge in his composition, a dreamer
whose philosophy is sleep and let sleep.

SAKI

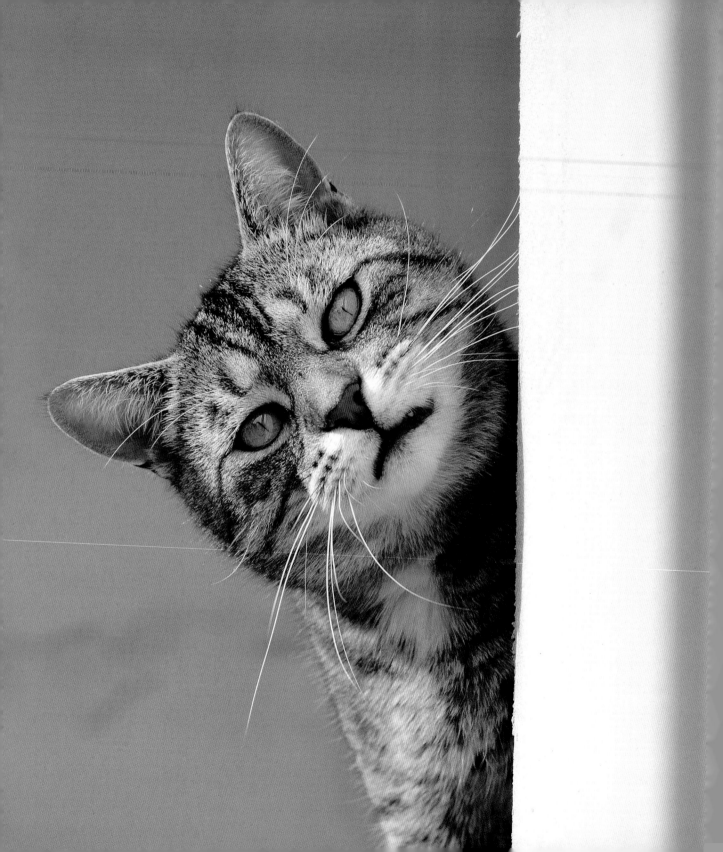

Cats come and go
without ever leaving.

MARTHA CURTIS

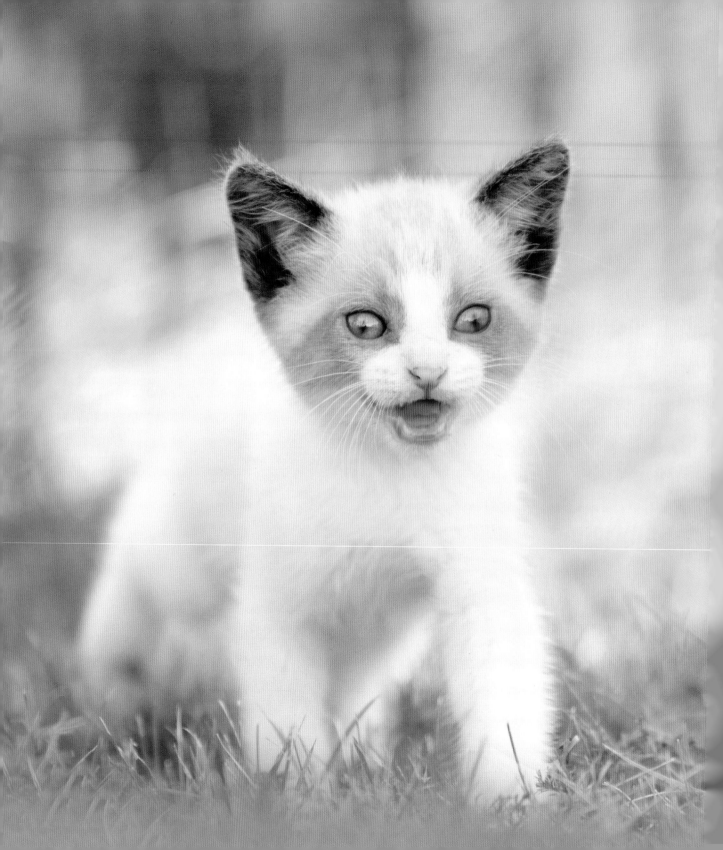

A kitten is chiefly remarkable for rushing about like mad at nothing whatever, and generally stopping before it gets there.

AGNES REPPLIER

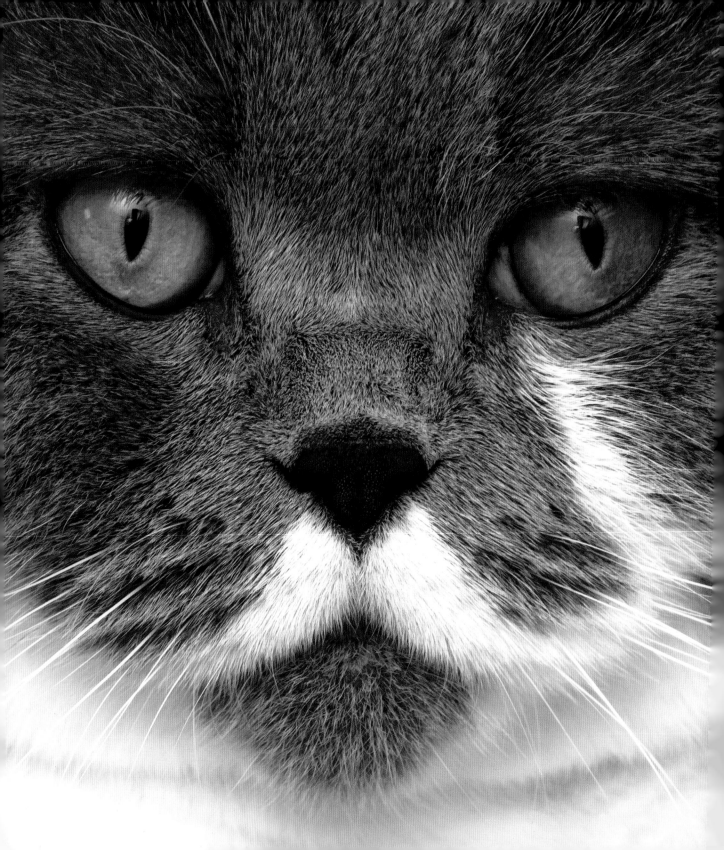

The purr from cat to
man says, 'You bring me
happiness; I am at peace
with you.'

BARBARA L. DIAMOND

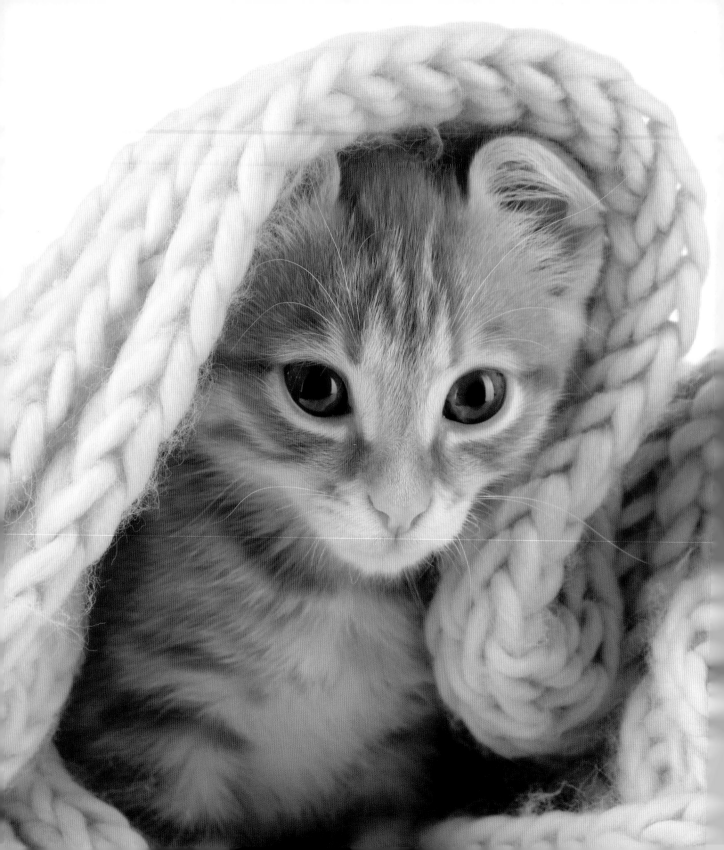

Cats, like butterflies,
need no excuse.

ROBERT A. HEINLEIN

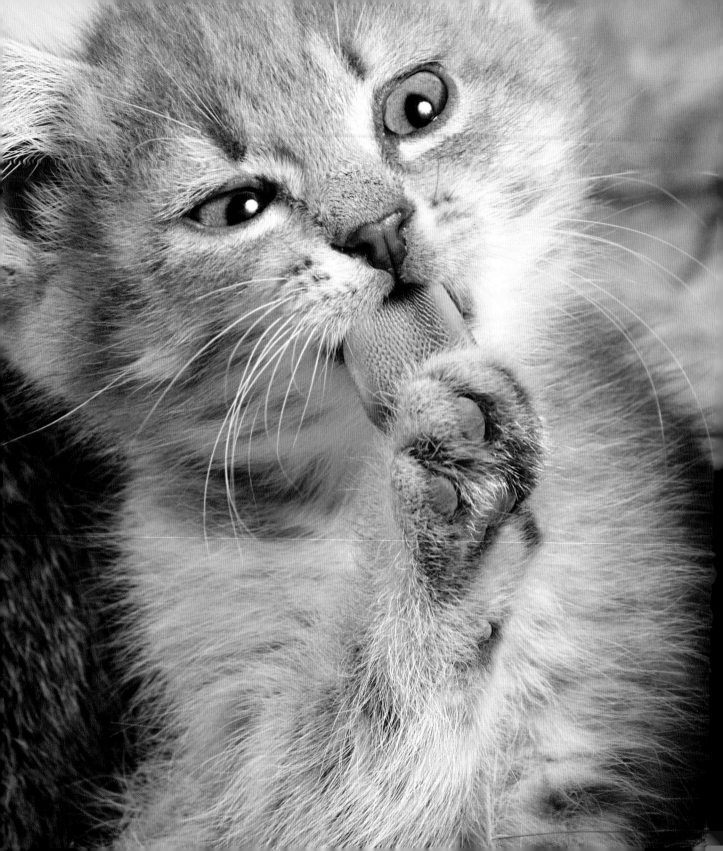

Just as the would-be debutante
will fret and fuss over every
detail till all is perfect, so will
the fastidious feline patiently toil
until every whiskertip is in place.

LYNN HOLLYN

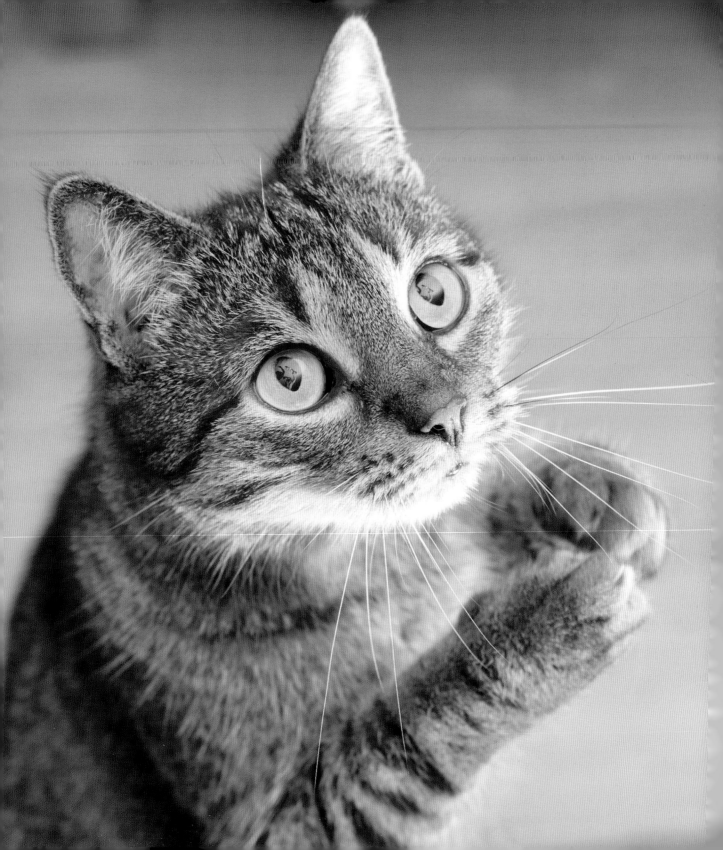

Cats know how to obtain
food without labour, shelter
without confinement, and love
without penalties.

W.L. GEORGE

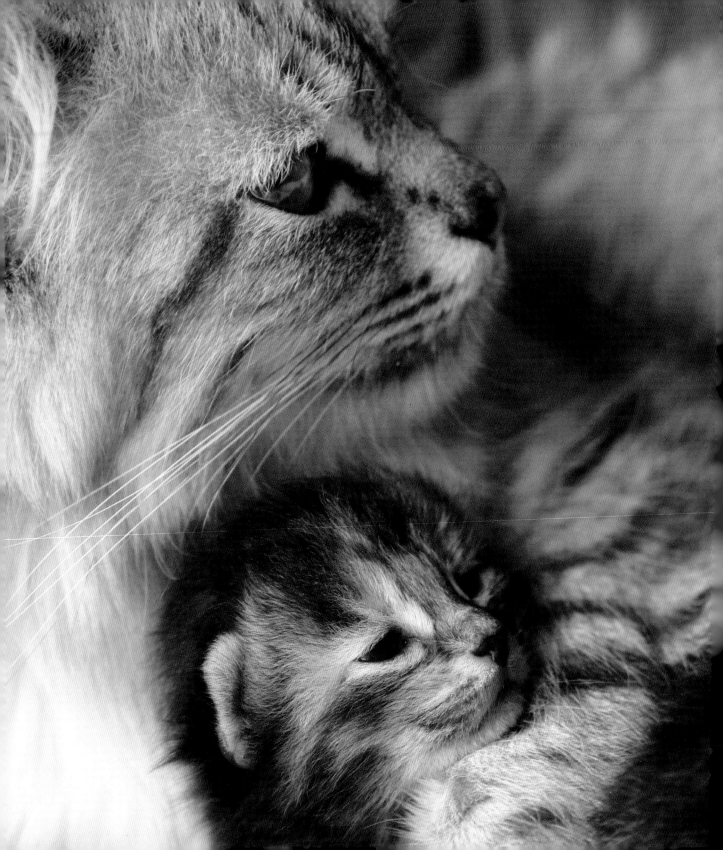

One cat just leads to another.

ERNEST HEMINGWAY

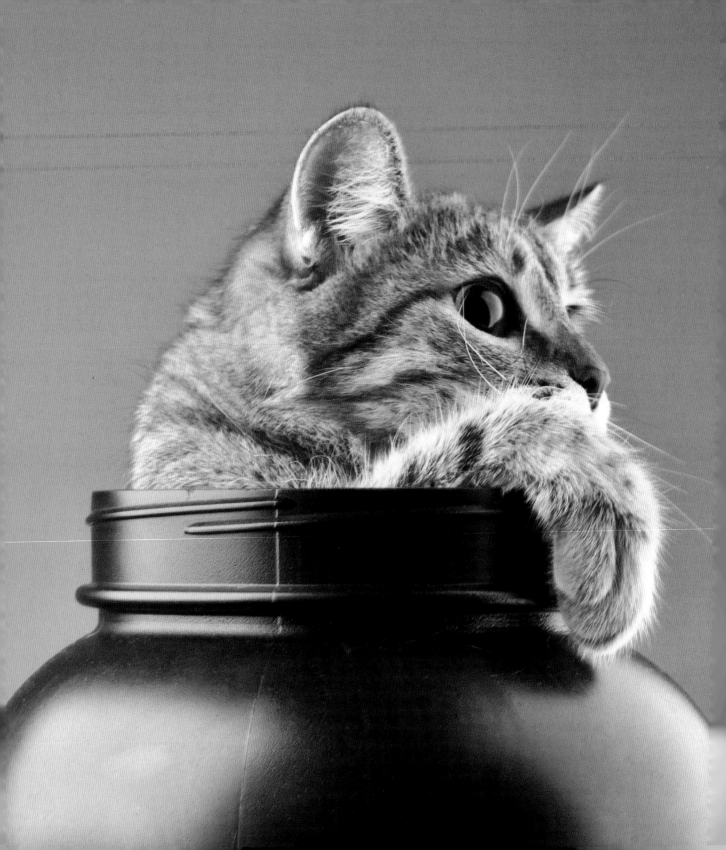

A cat will assume the shape
of its container.

UNKNOWN

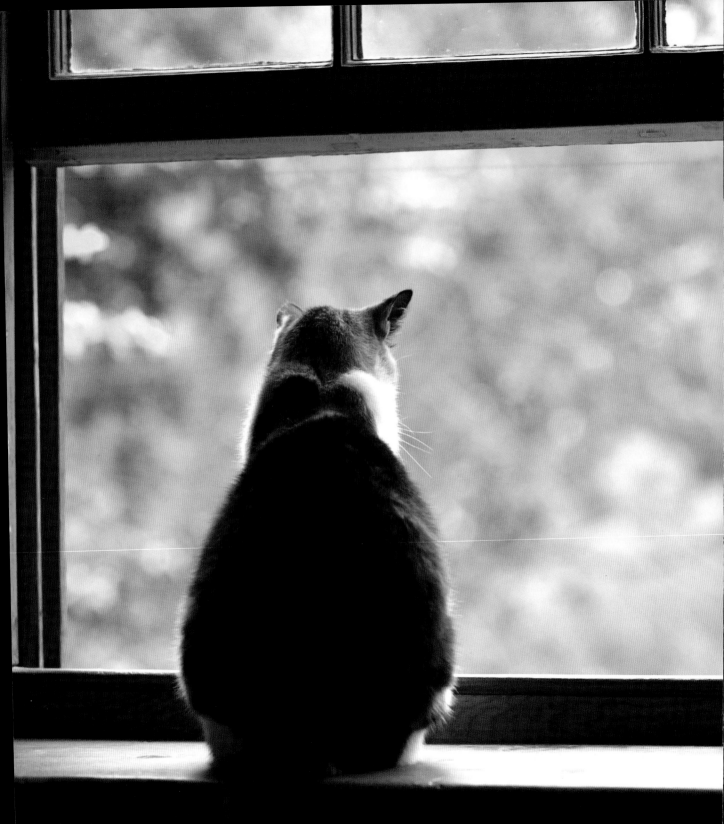

He lives in the halflights in secret
places, free and alone — this
mysterious little-great being whom
his mistress calls 'My cat'.

MARGARET BENSON

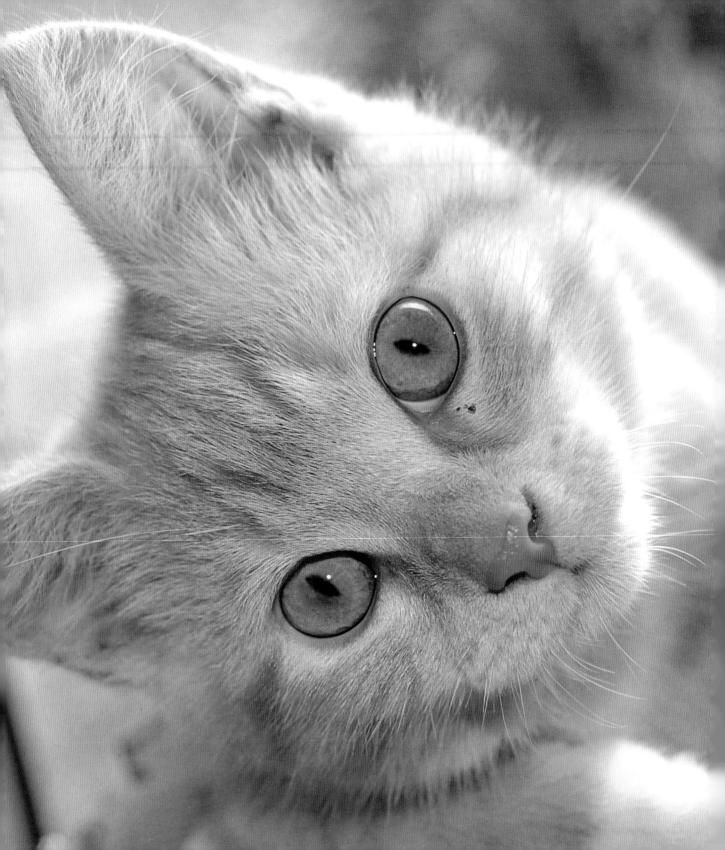

Most of us rather like our cats to have a streak of wickedness. I should not feel quite easy in the company of any cat that walked about the house with a saintly expression.

BEVERLY NICHOLS

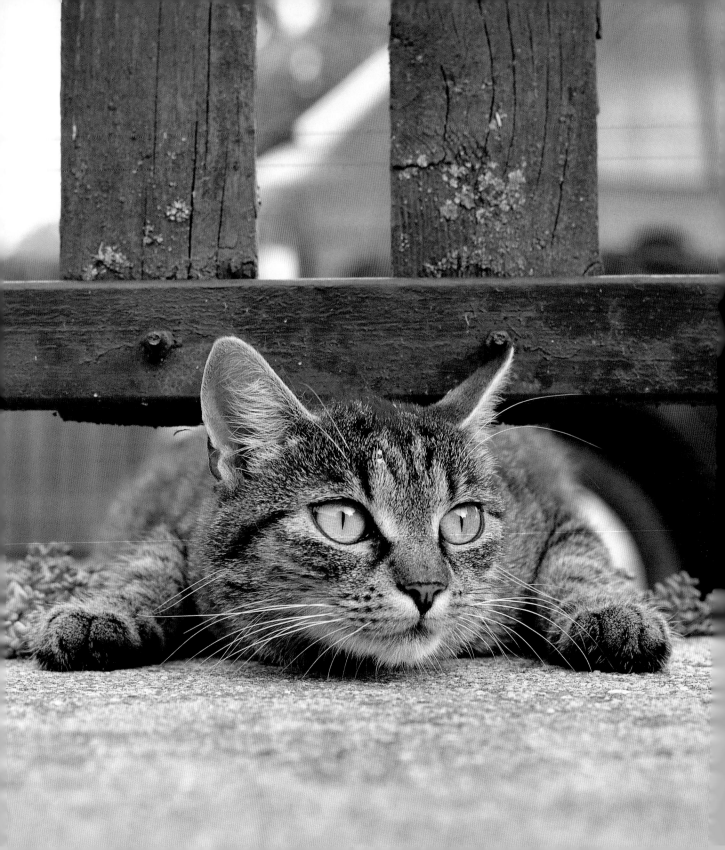

Always the cat remains
a little beyond the
limits we try to set for
him in our blind folly.

ANDRE NORTON

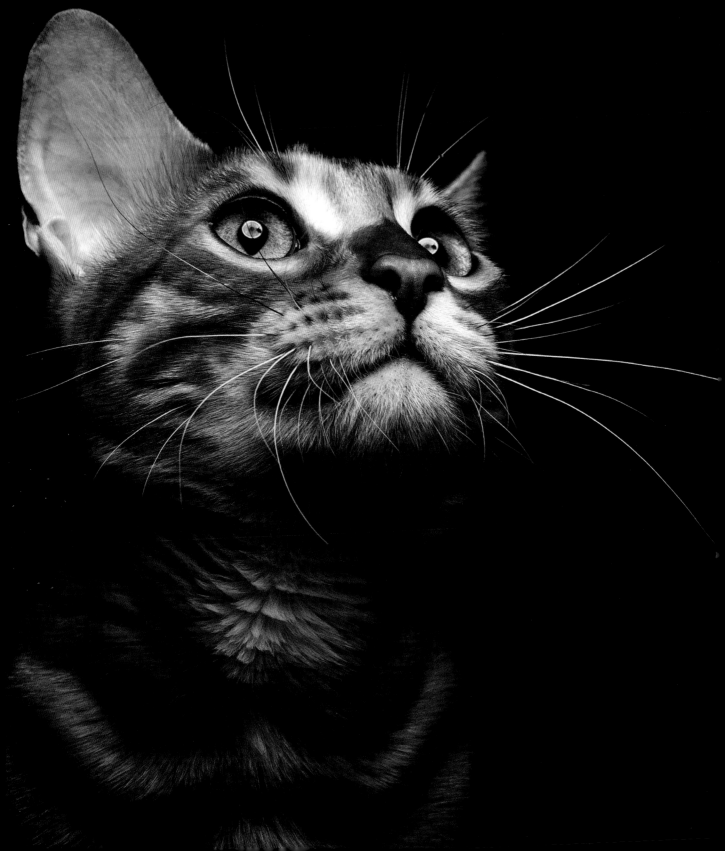

The cat has always been associated with the moon. Like the moon, it comes to life at night, escaping from humanity and wandering over housetops with its eyes beaming out through the darkness.

PATRICIA DALE-GREEN

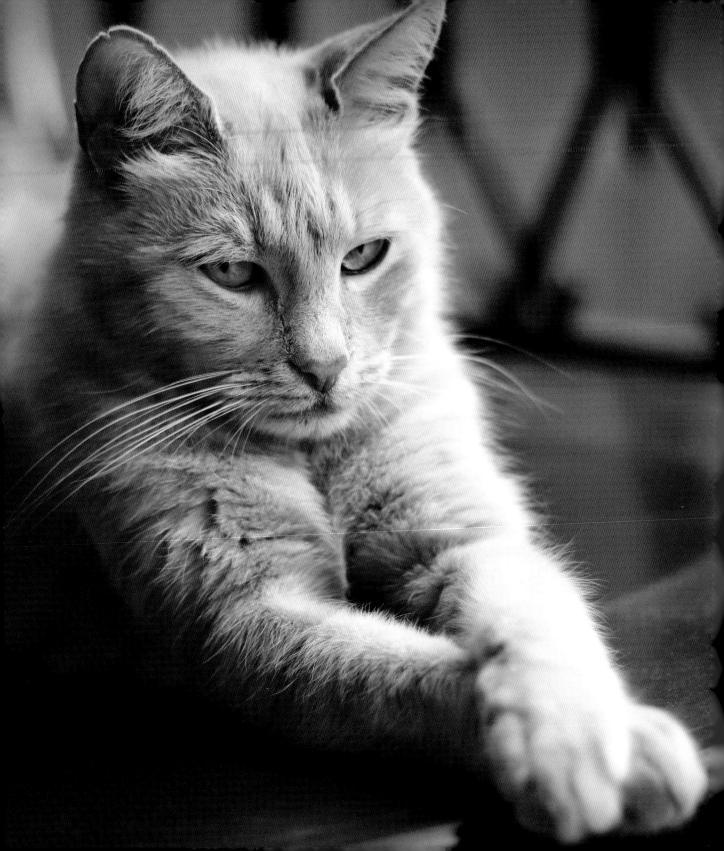

My husband said it was him
or the cat ... I miss him sometimes.

UNKNOWN

Also by Exisle Publishing …

WOOF

A book of happiness for dog lovers

ANOUSKA JONES

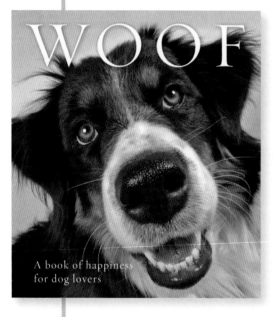

Dogs make our lives feel complete. They're there for us through good times and bad, with their wholehearted engagement in life a lesson to us all on 'living in the moment'.

This is the perfect gift for any dog lover, with its selection of quotes ranging from the serious to the light-hearted, accompanied by beautiful photography.

ISBN 978 1 925335 57 6 (paperback)
ISBN 978 1 925335 09 5 (hardback)

SPIRIT

A book of happiness for horse lovers

ANOUSKA JONES

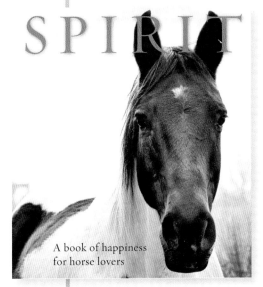

Horses are the epitome of grace, power, and freedom. They also have an ability to touch our souls and connect with our hearts in a way that few other animals can. From a little girl's first pony to a gnarled cowboy's last quarter horse, they can offer us some of our deepest friendships and inspire us to be the best version of ourselves.

Spirit: A book of happiness for horse lovers is a compendium of enduring quotes that capture the essence of our affection for these magnificent animals. Some are by famous people, others not; some are philosophical, others light-hearted — all are memorable. Accompanied by beautiful photography, and presented in a high-quality gift format, this is a collection of quotes to treasure.

ISBN 978 1 921966 95 8 (paperback)
ISBN 978 1 925335 51 4 (hardback)

First published 2014
This edition published 2022

Exisle Publishing Pty Ltd
PO Box 864, Chatswood, NSW 2057, Australia
226 High Street, Dunedin, 9016, New Zealand
www.exislepublishing.com

A CiP record for this book is available from the National Library of Australia.

ISBN 978 1 922539 03 8

Designed by Mark Thacker
Typeset in Archetype 24 on 36pt
Photographs courtesy of Shutterstock
Printed in China

This book uses paper sourced under ISO 14001 guidelines from well-managed forests and other controlled sources.

2 4 6 8 10 9 7 5 3 1

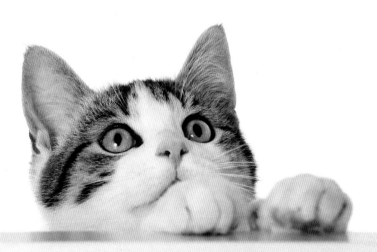